PHOTO/GRAPHIC DESIGN

PHOTO/GRAPHIC DESIGN

PHOTO/GRAPHIC DESIGN

The interaction
of
design
and
photography

Allen Hurlburt

Watson-Guptill Publications/
New York

First published 1983 in New York by Watson-Guptill Publications,
a division of Billboard Publications, Inc.,
1515 Broadway, New York, N.Y. 10036

Library of Congress Cataloging in Publication Data

Hurlburt, Allen, 1910-1983
 Photo/graphic design.

 Bibliography:p.
 Includes index.
 1. Photography 2. Graphic arts. I. Title.
II. Title: Photographic design.
TR147.H87 1983 770 83-14802
ISBN 0-8230-4005-4

Distributed in the United Kingdom by Phaidon Press Ltd.,
Littlegate House, St. Ebbe's St., Oxford

Manufactured in U.S.A.

First Printing, 1983
1 2 3 4 5 6 7 8 9 10/88 87 86 85 84 83

In Memorium

Allen Hurlburt worked right up to the end of his life. He was very near the finish of this book, his fifth, when his body let him down at last. As he had so many other times in a lifetime of achievement in the world of magazines and design, he asked his trusted friend and colleague William Rosivach for help. As always, Rosivach delivered. A few other friends helped as well, but this remains Allen Hurlburt's book. The last-minute changes that are normal with any book were minor in this case. They were made by people who knew Allen's mind, so far as it is possible to know the mind of a man who was singularly gifted in his work and in his vision.

Allen took the gift of life seriously, and did not squander it. He fundamentally changed the status of the art director in the hierarchy of publishing. In Hurlburt's view, an art director could not be a nonverbal specialist who made the printed page pretty after the serious work of writers and editors was finished. Words and pictures and typography all had to work together to serve the ideas being presented. Therefore, Hurlburt insisted, th art director had to be a powerful, instrumental participant in the entire editorial process, from the conception of a

story idea right through the execution of it and on into the printing plant.

Such notions seem obvious today, but they were not when Hurlburt began his career. The vision of the art director as a very senior editor is commonly accepted now because Hurlburt, by his example, showed how such a person could perform.

Hurlburt could not only do what he professed, he could teach it. He taught writers about pictures. He taught photographers about how words could ennoble their work. He taught other editors about the way all elements of a story can work together; if a headline wasn't right, he knew more than enough about the power of words to re-write it himself.

It must have been obvious to Hurlburt years ago that he had reached a unique standing in his field. He could hear the plaudits and see the plaques and statues and certificates of merit. He had an armload of those, but he never leaned back from the daily task of trying to do his work better. The man was tireless. As an executive, he was secure in himself, and he knew that he had to bring along other gifted art directors, even those whose ideas were different from his own. What mattered was high-quality work.

In the end, only death could stop him from searching for ways to improve the power of communication. Now, it is up to others, and in the days after his death, it was no surprise to hear the outpouring of love and respect that signaled their debt to Allen Hurlburt.

Contents

Introduction

Photo/graphic is not a new word but a fresh look at a designation that came into the language nearly one hundred and fifty years ago. It was first used by the astronomer and scientist Sir John Herschel to describe a process invented by his friend William Henry Fox Talbot, an English scientist, mathematician, and linguist, whose photographic inventions were at the root of the revolution in visual communication.

Sir John Herschel combined two convenient Greek words—*photos,* meaning "light," and *graphikos,* meaning "drawing,"—to describe a process he visualized as "drawing with light." He also originated the terms "negative" and "positive" to define the two steps that were basic to Fox Talbot's experiments, which brought with them a built-in opportunity for the duplication of images. These negative and positive images were to form the basis for all photographic images until the comparatively recent introduction of electronic technologies, which are yet to be fully realized.

In its earliest days photography drew its guiding inspiration from painting. Not only amateurs like Fox Talbot but such inventors and artists as Joseph Nicéphore Niépce and Louis Daguerre before him were all searching for ways to improve their drawing ability at the time they made their discoveries. Many of the pioneers of photography—Julia Cameron, Peter Emerson, Alfred Stieglitz, and even Edward Steichen in his early Photo-Secessionist period—made a special effort to introduce painterly effects to their photographic prints.

This interchange continues to our own time, but in the last half of the twentieth century, the growing forces of visual communication put a new emphasis on design and photography. During this period many design students began to experiment with photography, and many young photographers began to look toward design to increase the dynamics and strengthen the communication aspects of their images.

Beginning in the 1930s, a remarkable microcosm of this revolution was contained in a unique series of courses in graphic design and photography called the Design Laboratory. For several decades a brilliant Russian-born American graphic designer shaped a group of design and photographic students into an impressive group of photo/graphic designers. His name was Alexey Brodovitch, and one only needs to look at a partial list of his students to understand the far-reaching influence of his teaching: Irving Penn, Richard Avedon, Howard Zieff, Art Kane, Henry Wolf, Bob Gage, Helmut Krone.

A more recent, international recognition of the interaction of design and photography took place in Germany in 1969, when an association named *Bund Freischaffender Foto-Designers* (Association of Freelance Photo-Designers) was formed. This was perhaps the final, formal recognition that in visual communication, design and photography are often inseparable.

As a designer who has spent the better part of a career caught between these two art forms, and one who is even more concerned with the content of an image than its visual presentation, I have written this book in a search for a balance between design and photography. But juggling these two elements hasn't always been easy; I continue to have a great sympathy for the photographer's anguish when a picture must yield to the communication need, and I can still sense my own frustration when a photographer has delivered everything but the critical picture that will complete the editorial idea.

At this point, I am reminded of a time when one of many heated

debates between art directors and photographers ended abruptly at a bar after the photographer Arnold Newman's somewhat charitable comment that he had always looked on art directors as collaborators. Then, closing the argument to all further discussion, Henri Cartier-Bresson put down his Scotch and said, "In France, we used to shoot collaborators."

This book then is both a creative exploration of the interaction between these two significant disciplines and a reflection of my own years spent dedicated to both. As art director of *Look* magazine, I spent many long hours peering over light boxes or ensconced in darkened projection rooms studying thousands of color transparencies, and in addition to these I reviewed countless more black-and-white exposures. It was there that I felt the harmony that can exist between design and photography as well as the discord that can result from the clash of these volatile forces.

Drawing on both my own experience and a long study of the historic development of photography and modern graphic design, this book will concentrate on the creative opportunities that exist for both photographer and designer. It will also emphasize the creative rewards that await the contemporary designer in the understanding of photographic vision and the exploration of photographic technique. In addition, the book will clarify the advantages a photographer can gain from understanding design values and communication needs. Finally, it is hoped that an awareness of this interaction will lead to a better understanding of each discipline for the other and a mutual concern for the combined results of design and photography in visual communication.

The image develops

Similar to the photographic print taking form in the developer, the interaction of design and photography came into focus gradually. This section of the book traces that development, from the early influences of the camera obscura and the creative revolution that the invention of the enlarger made possible to the present advanced state of page design and graphic form.

Eye and camera: From the beginning our vision of reality has taken two principal forms: one is *cognitive,* based on a summary of visual experience that we have reassembled in our minds; the other is *perspectival,* based on an image seen from a single viewpoint, as through the lens of a camera. A cognitive view tends to identify a square table without distortion—all sides appear to be equal with all four corners at right angles to each other. On the other hand, in the perspectival view, we see the near side of the table as wider than the far side, and the sides further away from our view recede to a common vanishing point.

Today, most of us are inclined to take the single viewpoint for granted, but this is not a concept that is accepted by a fact, the concept of r resisted in primitive there is minimal exp photographic imag only come into our comprehension gradu there is impressive evidence tha the Renaissance artists, who did so much to advance the cause of scientific perspective, were influenced by the camera. No one knows exactly when the *camera obscura*—an early camera that was able to project images onto flat surfaces—was first invented, but we do know that the Greeks understood the principle of this

form
fifte

13

of projection, and that by the ...enth century these cameras had ...ecome fairly sophisticated. And by the sixteenth century, cameras had been refined to incorporate lenses and ground-glass reflectors, using mirrors to correct the upside-down and backward effects.

The interaction of design and camera probably predated the perspectival experiments of artists like Leonardo, Donatello, Uccello, and Dürer; and the revolution in pictorial realism that began in the Renaissance owes a principal debt to the new vision of reality that artists found in the camera obscura.

To understand just how important the camera's influence on painting was, we need to travel back in time and visit an artist's studio in Delft, Holland, toward the end of the seventeenth century. The artist was Jan Vermeer, and although he lived a century and a half before the invention of photography, his paintings reveal a strong connection to twentieth-century photographic images.

Vermeer's paintings have a quality of light that can be found in few paintings before or after his time; a study of his paintings reveals a

surprisingly close relationship between this light quality and the light found in modern photographic prints or transparencies. The dots of light that create a shimmering quality in his paintings accurately simulate a phenomenon otherwise found only in slightly out-of-focus photographic exposures.

Recently, Professor Charles Seymour of Yale University was able to duplicate photographically Vermeer's "points of light" by taking pictures of objects similar to those in Vermeer's paintings through a cabinet version of the camera obscura, which is similar to the

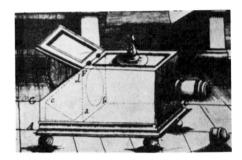

The camera obscura *(above), which projects an image onto a flat surface, was commonly used by artists in the sixteenth century. With this device, Jan Vermeer was able to capture a quality of light, unique to photography and invisible to the naked eye, in paintings such as* The Artist in his Studio *(right).*

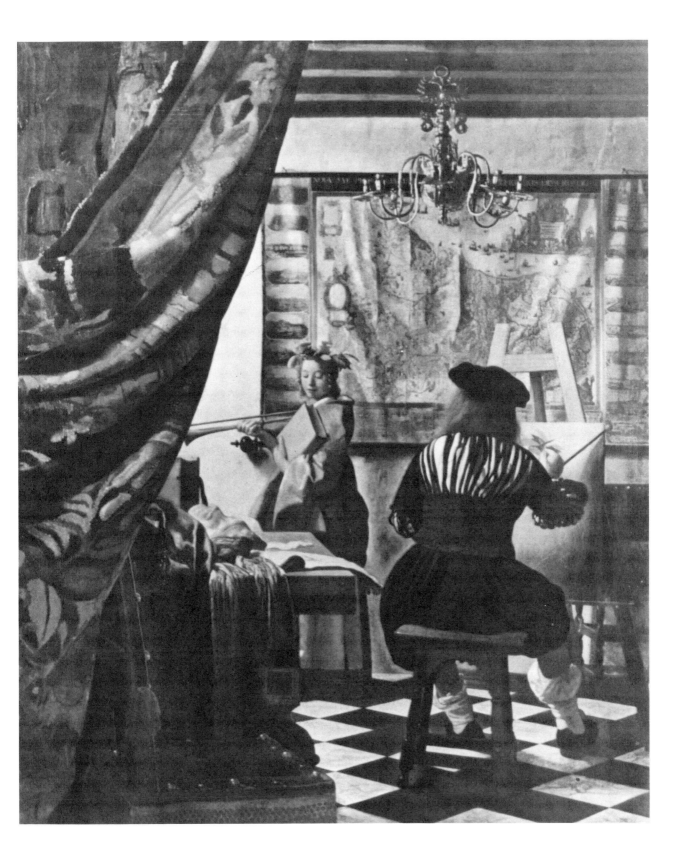

camera used during Vermeer's lifetime. Because these points of light or "circles of confusion," as Seymour called them, are unique to photography and cannot be seen with the naked eye, Professor Seymour has established that when we look at certain objects in Vermeer's paintings, we are in fact viewing a camera-related image.

There are several other points of

16

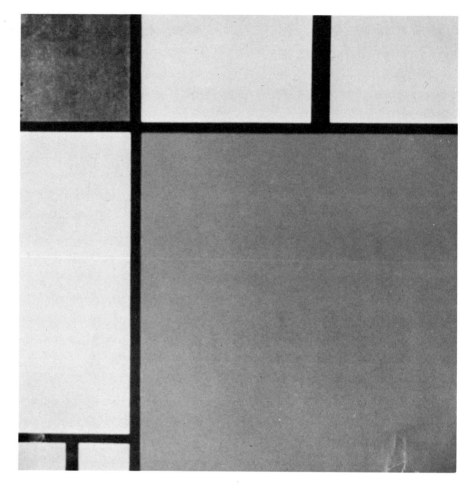

Note the parallel composition in Composition with Red, Blue, and Yellow, *1930 (above) by Piet Mondrian and Vermeer's* The Artist in his Studio *on the preceding page. Also, notice how the detail from Vermeer's painting (right), when cropped from the composition, can stand alone as a self-contained entity.*

similarity between Vermeer's seventeenth-century paintings and latter-day photography. For example, certain parts of Vermeer's paintings lend themselves to cropping; that is, a detail can stand alone and is aesthetically satisfying as a complete picture. In fact, many of these details suggest the differing views of various focal-length lenses and the effects of the zoom lens.

In using the cabinet-type camera obscura, Vermeer created some paintings from a viewpoint that was more akin to a waist-high camera position and not the normal position of an artist standing or sitting before an easel. In addition, Vermeer's concentration on the quality of light brought him a new appreciation of space and a simplification of composition, which foreshadowed

the twentieth-century designs of his fellow countryman Piet Mondrian (see page 16).

Although we have little documentation of Vermeer's life or the techniques he employed, his paintings do reveal a relationship to camera-generated images. Vermeer not only learned about pictorial reality and the precision of detail from the camera obscura, he

became one of the first artists to comprehend the special quality of the light that a camera reveals and its influence on space and design.

The frame and the viewfinder: The space and structure of our surroundings were the first influences on the form of visual images. From the natural niches of the Lescaux caves to the pristinely proportioned spaces of Palladian villas, the shape of pictures was naturally dictated by existing form. Later, of course, the proportions of art were also influenced by the geometric shapes of drawing pads and sketchbooks or the wooden panels and canvases of Renaissance and post-Renaissance painters. The shape and form of artistic composition stretched from the simple rectangle to the elaborate and ornate shapes of triptychs, stained-glass windows, and scrolls.

Under the influence of the camera obscura, Vermeer encountered a new determining factor of scale—if not size—as he began to study and compose his pictures with the help of the camera frame. This method of composition forecasted the way that modern photographers frame the defined image within the viewfinder or on the ground glass of their cameras.

In 1826, when Nicéphore Niépce pointed his crude camera through the window of his room in Gras, France, and recorded the first known photograph, its shape and size were dictated by the camera he used. Throughout the early history of photography, camera size had been responsible for the size of the image, a fact that explains the similarity in size of all original Daguerreotypes. As recently as 1900, when larger pictures were needed, the only solution was to build larger and larger cameras.

18

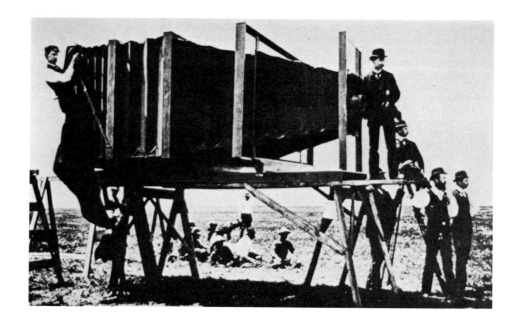

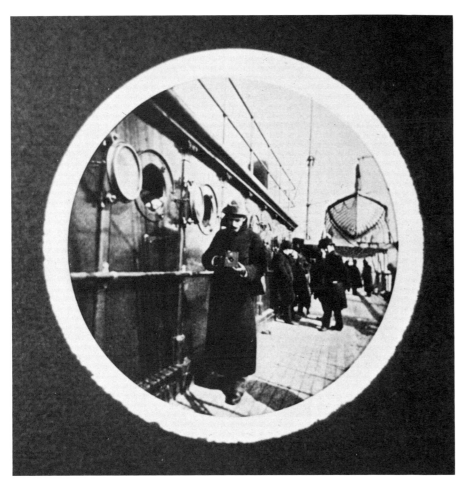

That same year in Chicago, a camera was constructed to take an eight-foot-wide picture of a railroad train (see page 18). It took a crew of fifteen men to operate it. The twentieth century was well underway before fast-film emulsion and practical enlargers made monolithic monsters like this camera obsolete.

Another technical development that influenced size and form was the pictorial surface. Fox Talbot had introduced the negative and positive process in 1840. He first used paper negatives but soon shifted to glass. Then, in 1883,

19

To make a 4¹/₂ × 8 ft. exposure, this giant camera, the Mammoth (left), was built in 1900. Weighing 1900 pounds (when loaded), it was operated by a 15-man crew. The shipboard snapshot (above) of George Eastman was taken in 1890 by Fred W. Church with the first Kodak camera, like the one Eastman is holding.

when George Eastman opened the door to snapshots and candid photography with his invention of the Kodak camera, a spool of negative-sensitized paper was used, but it wasn't long before Eastman switched to a cellulose-based film.

The film that Eastman used was to have a little known, but important, influence on the size of pictures to come. Thomas Edison, who at the time was experimenting with ideas for moving pictures, borrowed some of this 2½"-wide film and cut it in half. This film then became the foundation for 35mm movie film; it

The enlarger projects light through the negative and focuses it onto sensitized paper. By varying the distance between the enlarger's lens and the paper, the size of the image can be altered.

also eventually dictated the format of the 35mm still camera, when Oskar Barnack, the inventor of the Leica camera, turned the film on its side to provide the 24 x 35mm format for the Leica.

Only three of these film sizes have a common proportion—the 8 x 10 view camera, the 4 x 5, and the comparatively new 110 size. None of the proportions fits the more or less standard American 8½" x 11" page size; and only one—the rarely used 5 x 7 format—matches the European standard A4 proportion, which is based on the root 2 rectangle.

Common Film Sizes

Type	Size (in.)	Size (mm)
Sheet film	11 x 14	283 x 353
	8 x 10	202 x 253
Film pack	5 x 7	122 x 178
	4 x 5	101 x 127
Roll film		
120	2¼ x 2¼	57 x 57
35mm	⅞ x	
	1⁷⁄₁₆	24 x 35
110	½ x ⅝	12 x 17

This table of standard film sizes indicates how random most of these proportions are.

This brief look at film and camera sizes casts some doubt on the absolute validity of the photographer's viewfinder in the determination of picture proportion.

The image enlarged: Perhaps the real unsung hero of the photographic revolution was the enlarger. Scores of books have been written about cameras and their influence on contemporary photography; but aside from a few technical manuals, there is little acknowledgment of this instrument of photographic magic. Yet, it was the enlarger that made it possible

for the photographer to take a second look; that introduced a freedom of choice by permitting the use of small, inexpensive film sizes and small, convenient, and flexible cameras; and that gave the photographer another opportunity to control the light and modify the image as the light moved from the negative to the positive print.

One of the first photographers to seize on the selective opportunities of the enlarger was the American pioneer photographer, Alfred Stieglitz. When the first small-format cameras began to appear at the end of the nineteenth century,

Stieglitz worked with one of them and made this comment about his experience: "My small-camera negatives are made with the express purpose of enlargement, and it is but rarely that I use more than part of the original."

The subject of darkroom selectivity and picture cropping has been at the center of the long debate between the photographer and the art director. Even today there are a few photographers who resist the enlarger and insist on only contact prints of their large-format negatives. Others, such as Henri Cartier-Bresson, are adamantly

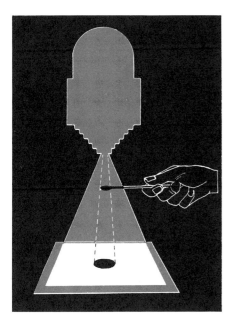 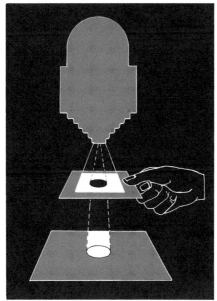

Dodging (above) allows you to decrease intensity, lightening a portion of the image, by reducing the amount of light that strikes this area of the print. Burning in *(right) allows you to increase intensity, darkening a portion of the image, by reducing the amount of light that strikes all other areas.*

opposed to the cropping of their prints, and an art director working with Cartier-Bresson's prints must learn the discipline of layouts without cropping. But these examples are exceptions; most designers and photographers working in visual communication have a less pure attitude toward picture cropping and picture use. They tend to use both methods, which only maximizes the possibilities for the best composition.

Summary: The interaction of camera image and design or composition had its origin in the influence of the camera obscura. This unique contrivance assisted the Renaissance artists in their development of scientific perspective in their paintings; and later, particularly in the work of Jan Vermeer, the camera obscura helped bring a new dimension of light, space, and form to artistic vision.

When the camera obscura method was finally able to produce a lasting print, the proportions of an image were determined solely by the plate size. But by the turn of the twentieth century, the invention of the enlarger and the development of faster film emulsion broke through this constraint and permitted a free choice of size and shape. The enlarger has long been underrated as a photographic instrument, but without it the photo/graphic revolution would never have taken place.

The enlarger brought compactness, convenience, and economy to photography by making the small camera practical. It also introduced darkroom control, making it possible for photographers and laboratory technicians to modify and enhance the final image. The enlarger made the manipulation of

images possible and became the principal instrument in the development of the photo/graphic effects. By dividing the exposure between different negatives and combining images; by adding screens and textured surfaces; by forcing contrast or softening the contours of an image; and by introducing flashes of light to create solarization effects, a whole range of graphic modifications became available to the photo/graphic designer.

Enlargement and image

At about the same time that Piet Mondrian was entering the mature phase of his Neoplastic art, the imaginative graphic images below were being designed by an American photographer. He had started life as a painter, but late in the nineteenth century, he succumbed to the new and exciting art of photography. His reputation as a photographer was soon established, and his work includes many experimental excursions: he once photographed an ordinary cup and saucer one thousand times in order to study the relationship between light and shadow. His name was Edward Steichen and

these designs were made for a fictitious work he called *The Oochens*. (The one on the left in the reconstructed version below is called "The Radio Gull," and the one on the right is a philosopher Steichen named "Thinkrates.") Each of the designs is composed of triangles using the proportions of the extreme and mean ratios of the artist's "golden section."

The Steichen contribution: Probably no photographic pioneer did more to bridge the gap between photography and communication than did Steichen. He was one of the first to recognize the potential of

the graphic content of photographic images, a fact that is aptly demonstrated in his 1903 portrait of J. P. Morgan (see page 68) where Morgan's hand on the arm of a chair gives the illusion of a hand holding a dagger.

In 1923, shortly after completing his designs for *The Oochens*, Steichen made a decision that was to have a far-reaching influence on photography as a communication medium. He accepted an appointment with Condé Nast publications as chief photographer for both *Vogue* and *Vanity Fair.* At roughly the same time, Steichen

made what may be an even more important move: he began to do advertising photography, where his keen eye brought a new vision, and his stature and reputation as a photographer of quality brought a new value—both aesthetic and monetary—to this important area of visual communication.

As an editorial and advertising photographer, Edward Steichen was responsible for several important innovations in photographic images. When he combined a picture of Greta Garbo with a picture of a camellia, he was one of the first photographers to create composite photographs in

This carefully planned composition on Charlie Chaplin, created in 1931 by Edward Steichen for Vanity Fair *magazine, imaginatively combines the two critical elements of page design: photographic style and strong editorial content.*

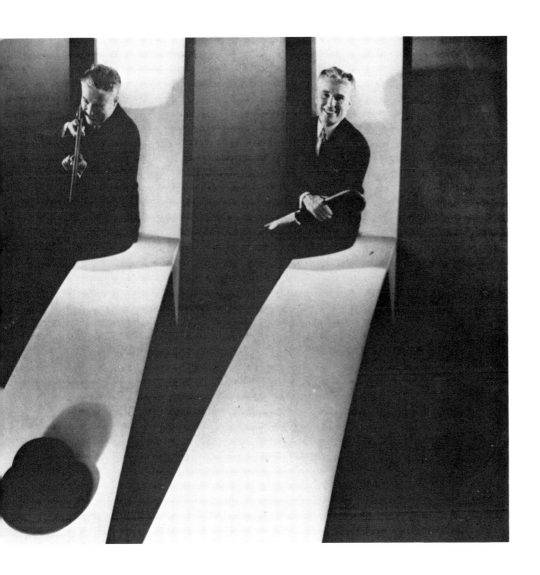

27

color. In another example, Steichen had the vision to combine his storytelling sequence on Charlie Chaplin into a single-composite photo/graphic composition (see pages 26-27). Steichen, in his famous series for Cannon towels, was also the first photographer to introduce the nude to advertising. Without the enlarger many of the effects that Steichen achieved would have been impossible, but an even more direct demonstration of the enlarger's influence can be found in the work of two other important photographers, Henri Cartier-Bresson and Ansel Adams.

28

The enlarger, two views: Anyone who has had the privilege of watching Henri Cartier-Bresson at work is immediately impressed with the way his beat-up-looking Leica, with its black finish worn down to brass, becomes part of the man, and, in turn, the man becomes part of the scene as he searches out what he was to label "the decisive moment." That term has often been misunderstood: Cartier-Bresson did not use it to refer to an irretrievable accident in time, but to that moment of decision when the photograph takes its full form—when the final design is clearly established. His work with the 35mm camera would

have been impossible if the practical enlarger and fast-emulsion film had not been developed.

Another photographer working in a very different way suggests a further contribution of the enlarger to the photographic revolution. While Cartier-Bresson with his pockets stuffed with rolls of film faded into the background and took countless pictures of "the flow of life," an equally renowned photographer named Ansel Adams made his camera dominate the environment. It was not uncommon for Adams to go after a single photograph with his view camera

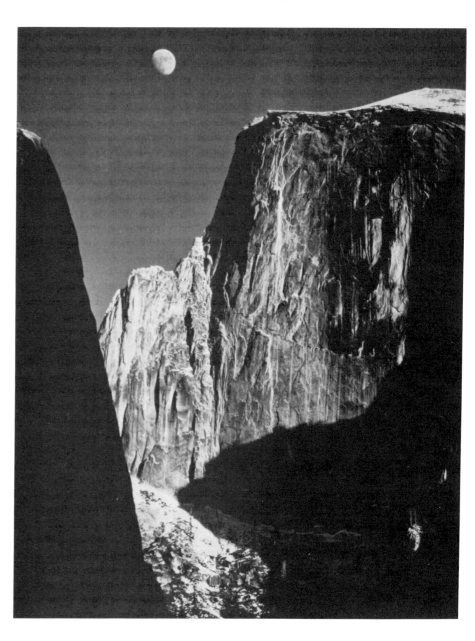

With the enlarger, Ansel Adams was
able to carry control of tone past
the moment of exposure and create
"perfect prints" like Moon over Half
Dome *(left)*. For Henri
Cartier-Bresson, the enlarger and
fast emulsion film allowed him to
use a 35mm camera to catch such
"decisive moments" as this 1935
candid, Callejon of the Valencia
Arena *(above)*.

over his shoulder and his film loaded in a plate holder that would permit only one or two exposures.

Ansel Adams's unmatched sensitivity to light and tone values is basic to his photography, from the careful study that often preceded the exposure to the precise rendering of the gray scale under the enlarger's light on the finished print. His approach demonstrated another important contribution of the enlarger. By creating a space between the subject in its negative form and the print, the enlarger made it possible to measure and control the final result through the manipulation of light. This is most often achieved by either *dodging* (see page 21), blocking off portions of the print by shading it with an opaque object during the exposure; or by *burning in* (see page 21), masking out the exposure except for a small beam of light. The size of the light beam can then be controlled by its proximity to the light source.

Ansel Adams gave up a promising career as a concert pianist to become a full-time photographer. His scale became the gray scale, and the darkroom and enlarger became his instruments of interpretation. Adams puts great emphasis on the quality of the finished print, and he often produces prints for a specific purpose, such as the reproduction by a specific process or for printing on a particular paper (see page 28).

Images in nature: A new appreciation of the natural world probably began with the early experiments of Fox Talbot, who found new beauty in the commonplace by taking pictures of such everyday objects as a broom in a doorway or a handful of flowers laid on a sensitized sheet of paper. From the beginning, photographers

30

Weed Against Sky, *1948 by Harry
Callahan (left).* Sand of Camargue,
1974 by Lucian Clerque (above).

have sought out the unusual and the unexpected in nature and the landscape to form images that were often more graphic than pictorial. This tradition guided such pioneer photographers as Edward Weston, Paul Strand, and Walker Evans. Two photographers who especially excelled at this technique were Harry Callahan and Lucian Clerque.

Harry Callahan brought together the vision of a Edward Weston and the experimental techniques of photographers such as Man Ray and László Moholy-Nagy. Callahan's photographs were frequently expressed with the simplicity of a line drawing (see page 30) as he sought out the expression and rhythm of the images in modern art, but he never completely lost contact with the reality of his subject matter. He did take advantage of accidents that sometimes aided in the transfer of these real images to graphic form.

Like Callahan, Lucian Clerque worked in the shadow of interpretive photography that searched for graphic images in the patterns of nature. Where Callahan concentrated on a cool, almost analytical, approach in his photography, Clerque followed a more impressionist direction, an approach that prompted Picasso to refer to him as "the Monet of the camera" (see page 31). The two pictures on these pages represent only a small sample of the hundreds of images produced by scores of photographers that demonstrate the camera's ability to find graphic expression in nature.

While photographers like Callahan and Clerque were finding graphic quality in the landscape, other photographers were discovering the power that dynamic design could bring to other subject matter. The famous portrait of Igor

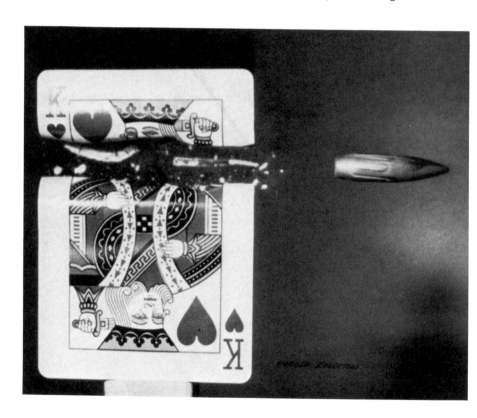

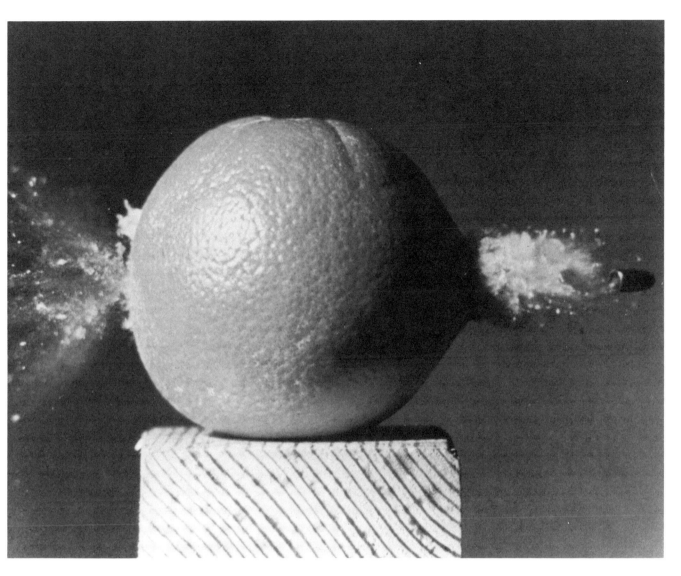

Stroboscopic photography made Harry Edgerton the first photographer capable of freezing motion.

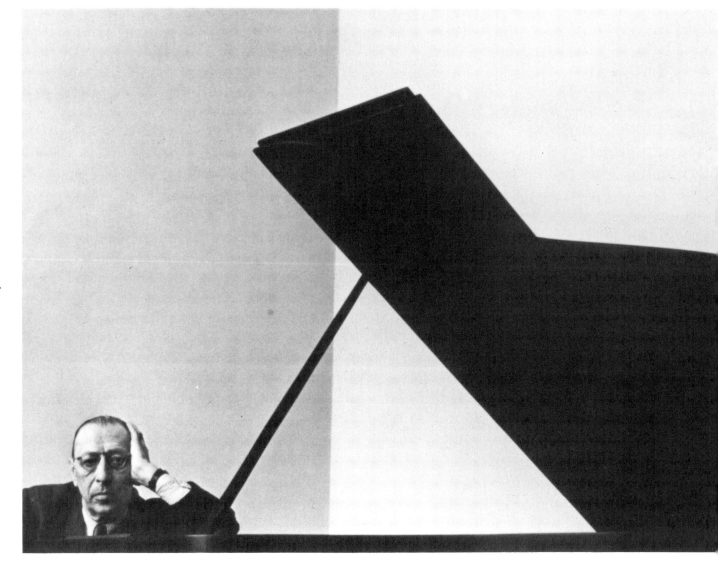

Igor Stravinsky, *1946 by Arnold
Newman.*

Stravinsky by Arnold Newman (see page 34) brings the force of a Mondrian composition to this significant photographic statement.

Lensless photography: In his search for new graphic images in the photographic medium, Man Ray was one of the first to turn away from lens-oriented images and endeavor to create abstract and semiabstract effects on the surface of his photographic prints. This technique is probably an extension of a process explored nearly a hundred years before Man Ray's time, when Fox Talbot made a direct exposure on a paper negative by laying a few flowers on sensitized paper under the sunlight; however, Man Ray had the advantage of using the enlarger as his source of light. Man Ray was an American artist–photographer living in Paris at the time he began experimenting with the manipulative aspects of darkroom technique. In his experiments, he was able to add the control of separate small beams of light to the objects on the photographic paper; he also discovered that by giving an exposed image a second, brief exposure of light before developing it, he could produce an effect called "edge reversal." This caused the

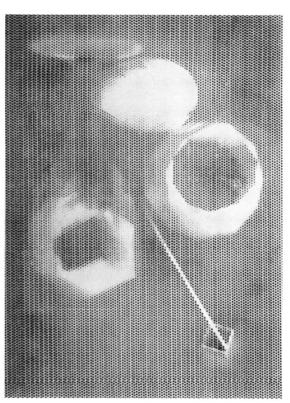

American artist-photographer Man Ray called lensless exposures like this "rayographs," but it was the Hungarian designer Lázló Moholy-Nagy's name for this process, "photograms," that stuck.

developed image to have a reversal of tones along its sharp edges. This effect, which has been widely used to create photo/graphic effects in both color and black and white, is usually referred to as "solarization," but it is more accurately identified as the Sabattier effect. The term solarization more correctly identifies a similar effect achieved by gross overexposure, but because of its broad and general acceptance this book will use the term solarization to cover both processes.

In 1921 Man Ray began his experiments with what he called "rayographs." At the same time Moholy-Nagy, an Hungarian designer in Germany, discovered this same process of lensless photography; he called his images "photograms." The photogram began like the rayograph, with the placement and removal of three-dimensional objects on sensitized photographic paper. Originally, these objects were illuminated by the single light source of the enlarger, which emphasized their contours as the light found its way around the dimensional edges and cast shadows. Later, when a small beam of light was added, greater control over the edges and the shadows was possible. Sometimes textures were added to all or parts of the background (see page 35). Although the resulting image from a photogram is often abstract and aesthetic, these images can also be used very effectively in graphic communication.

Action in nature: In 1878 the limitations of the human eye were convincingly demonstrated when the camera of Edward Muybridge established that no one had ever accurately observed the exact form of a galloping horse. Muybridge and the American artist Thomas Eakins went on to develop some

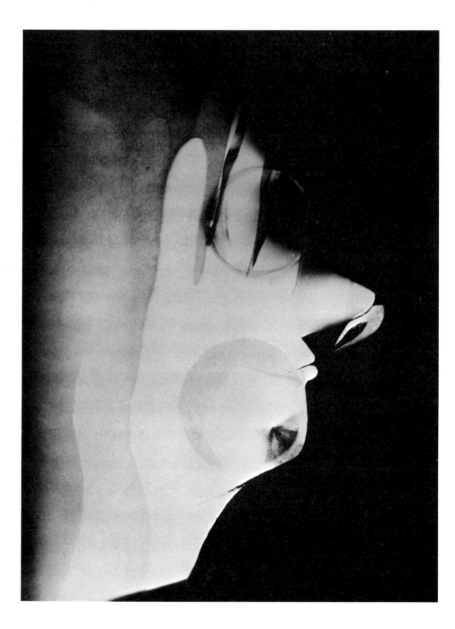

Left, an early Moholy-Nagy photogram, 1922-23. Above, a detail from his mobile metal construction, Light Space Module, *1922-1930.*

impressive images of action with the camera before the end of the nineteenth century, but it remained for scientist and photographer Harold Edgerton of the Massachusetts Institute of Technology to open our eyes to the as yet unseen action of high speed. In 1931 Edgerton designed an electronic lamp in which the current built up in a condenser to a high voltage that eventually discharged into a gas-filled tube. The resulting flash of great intensity but extremely brief duration could then be repeated at set intervals for sequential exposures. This was the first use of the stroboscopic effect,

which was to have an enormous influence on the future of photographic lighting.

If Edgerton's invention had a revolutionary effect on the professional photographer, it came to have a somewhat different meaning for him. His vision permitted him to see other possibilities in this remarkable light source, and he began to apply the method to a scientific exploration of the mysteries of high-speed action. Edgerton's photographic studies of a falling milk drop, pouring liquid, and the trajectory of a bullet not only effectively froze action, they

served a serious purpose for modern science as well. These photographs also created a portfolio of impressive graphic statements (see pages 32-33) that were to influence the approach of scores of contemporary photographers.

The posters of A. M. Cassandre: Some readers will wonder why I have chosen to include the poster designer A. M. Cassandre among those who have had a major influence on the development of photo/graphic design. After all, he was never seen behind a camera and even photomontage was not a

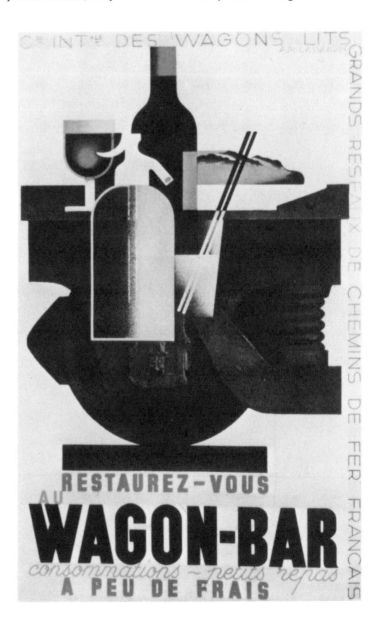

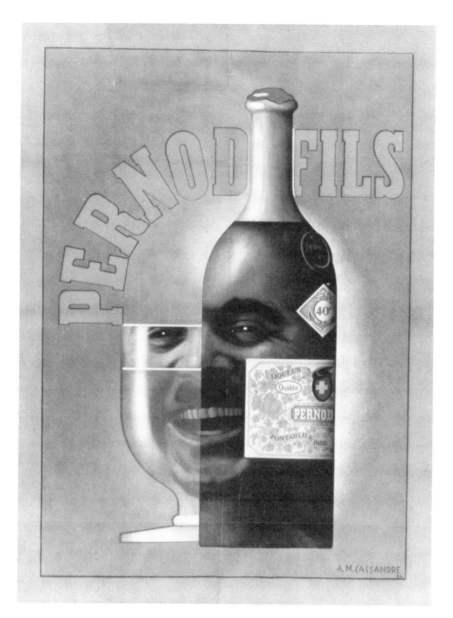

medium for which he had a particular fondness. However, there is ample evidence that he was aware of both the Russian Constructivist experiments and the work going on at the Bauhaus with collage and photographic composites. But, perhaps, the real reason for his inclusion here is that, in my opinion, he has had a greater influence on modern graphic design than any other single figure.

It wasn't until 1932, when he completed the *Wagon Bar* poster (see page 38), that Cassandre introduced montage to his poster designs; but when he did, he

Influence of photo collage on illustration is apparent in the posters of A. M. Cassandre: Pernod Fils, 1934 *(above) and* Wagon Bar, 1932, *(left).*

created a near-perfect blend of photographic and nonphotographic elements. *Wagon Bar* is also an expression of the doctrine of *purism,* with its carefully formulated rules of color and form, that had been advanced by the architect Le Corbusier.

In the *Pernod Fils* poster (see page 39), there is a more humorous use of the photographic technique. Cassandre has added so much painting to the smiling face that the viewer can only guess whether it is a photograph or a painting based on a photograph, but the effect remains the same.

Even in the main body of his work, where no photographic images occur, Cassandre's designs often reflect the forms of the photo-collage experiments that were sweeping across Europe during the 1920s. These Cassandre posters went on to influence a generation of designers who were to finally establish the photo/graphic connection with design.

The Russian influence: Perhaps the designer who did most to establish the vital connection between Russian Constructivism and the beginnings of photo/graphic design was El Lissitzky. His early work with

the Russian Cubists Kasimir Malevich and Vladimir Tatlin had brought him into direct contact with the vortex of the Constructivist revolution; and later, when he worked in Europe from 1922 to 1925, he had an opportunity to blend his ideas with the more sophisticated Western movement. There, he made contact with the Bauhaus designers and with Theo Van Doesburg, the leader of the de Stijl movement.

El Lissitzky was among the very first graphic designers to recognize the potential of photography in printing and graphic design. He pioneered

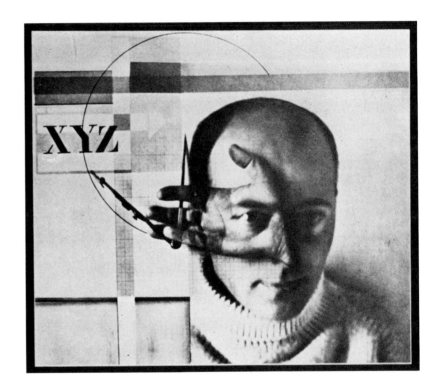

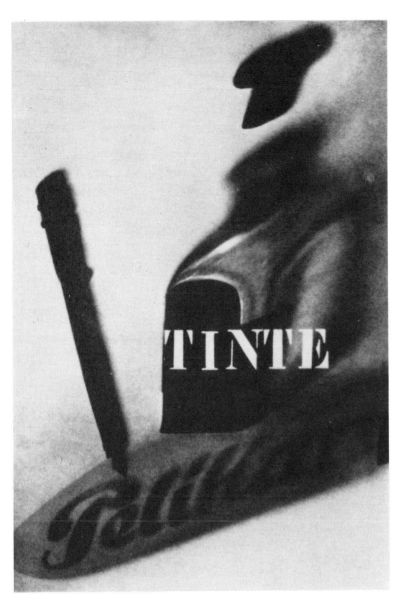

the effects of superimposition with double exposure and lensless photography, although he avoided such techniques as collage and photomontage in his own designs. An example of Lissitzky's vision and foresight in graphic design can be found in his prediction that photomechanical techniques of reproduction would eventually eliminate the tight rectilinear restrictions that metal type, engravings, and traditional make-up had placed on the printed page. This revolution is only now being fully realized as new electronic techniques are changing the process yet again.

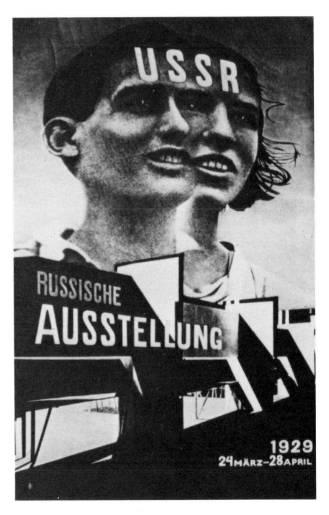

Piling on images, superimposing them by double exposure or lensless photography was pioneered by the Russian designer El Lissitzky in works like his 1934 graphic self-portrait, The Constructor *(left). Note the lensless images of a pen and the shadow of an ink bottle in his 1934 poster for Pelikan Ink (above) and how Lissitzky used photo techniques in this 1929 poster for the Russian Exhibition in Zurich (right).*

A pioneer of interaction: There is probably no designer in this century who better represents the interaction of design and photography than Herbert Matter. This may be—at least in part—the result of one of those fortuitous accidents that sometimes occurs in the graphic design profession. One day when Matter was living, working, and teaching in Paris, one of his students inadvertently left his camera in Matter's studio; and unable to resist the temptation to play with this new-found toy, Matter spent the rest of the day teaching himself photography.

From that day on, Matter's work became an uncanny blend of photography and graphic design. When he wasn't combining them, he was either an outstanding photographer or a top-flight graphic designer as the occasion demanded; but his strongest influence on visual communication has been the synthesis of both these art forms.

Herbert Matter, a Swiss-born designer, began his studies at L'Ecole des Beaux Arts in Geneva, but he soon shifted his attention to Paris, where he worked under A. M. Cassandre on posters and with Le Corbusier on architecture and three-dimensional design. One of

42

As a photographer, Herbert Matter, a designer who worked with both Cassandre and Le Corbusier, used this image (left) to illustrate Lucretius's concept of contentment in a series of magazine advertisements, "Great Ideas of Western Man," for Container Corporation of America. His reputation as a designer grew during the early 1930s with a series of posters for the Swiss National Tourist Office, including the example above.

his earliest teachers in Paris was Fernand Léger, an artist who has also had a powerful influence on modern composition.

The Matter reputation was made when a lapsed passport forced his return to Switzerland where he won a commission to do a series of posters for the Swiss National Tourist Office in the 1930s (see page 43). In 1936 he moved his base to America where he has continued to enhance his reputation with his design and photography for scores of American publishers and corporations.

The American influence: The graphic revolution that set the stage for photo/graphics began in Europe. American designers became aware of the new ideas through the expansion of international communication, through such exhibitions of European art as the Armory Show of 1913, and through the great migration of European designers to America that took place in the 1930s. Herbert Matter was only one of this impressive group that came to America, which also included Herbert Bayer, Moholy-Nagy, Alexey Brodovitch, Dr. M. F. Agha, and Will Burtin.

Among the first American designers to respond to the influence and add their own contribution to the graphic design revolution were Paul Rand and Lester Beall. They led a generation of designers who so reshaped American visual communication that by the end of World War II their work was influencing European design.

Like Cassandre, Paul Rand felt the influence of photography, but he didn't let the emphasis on photo/graphic effects prevent him from developing his own highly personal style. On many of his

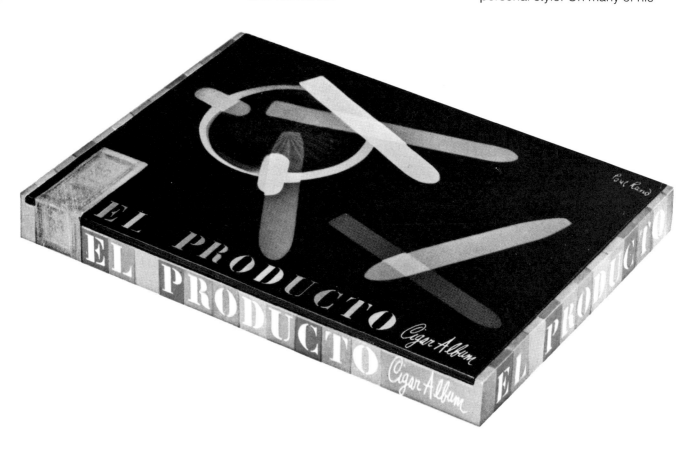

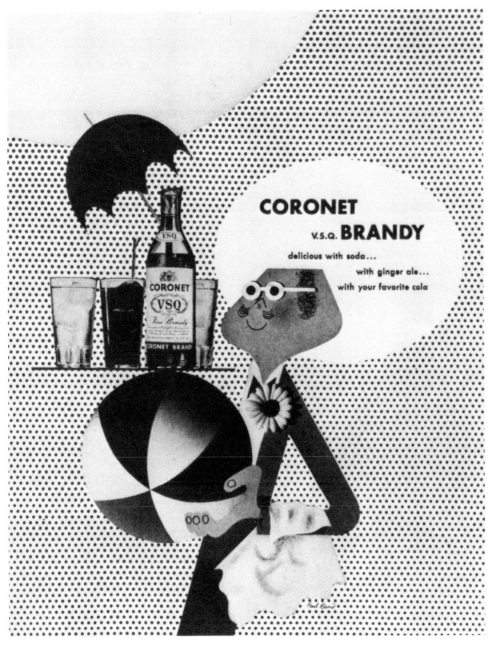

Designer Paul Rand rarely used
photographic effects, like the
photogram in his gift package for El
Producto Cigars (left). When he did,
the effect could be stunning. The
constructivist influence is obvious in
his collage-derived illustration for a
Coronet Brandy advertisement
(above).

advertisements he used a form of artwork that was assembled and prepared for camera reproduction. Although this work was related to the collage and montage effects, Rand's designs were more refined. He used photographic devices like photograms rarely, but when he did they were always outstanding. His photogram of an abacus was not only the cover for his own book, *Thoughts on Design,* it was also adapted into a fabric design that won a special citation from *Interiors* magazine. Some years later, when he designed a special gift package for El Producto cigars (see page 44), Rand used a photogram again to emphasize the variety of shapes of the cigars; he eventually won a gold medal at the Art Directors Club exhibition for this design.

Summary: One of the first photographers of stature to bridge the gap between art and design and photography was Edward Steichen. His early experiments in both photography and design made important contributions to the future of photo/graphics. Steichen's editorial photographs for *Vanity Fair* and *Vogue* brought a new excitement to editorial communication, and his advertising photography brought a new dimension and a new price scale to that profession.

None of this would have been possible without the enlarger, that magic instrument that influenced the careers of such different photographers as Henri Cartier-Bresson and Ansel Adams. It was the enlarger that made the compact and unobtrusive camera practical and that made the photographic darkroom a center of creative activity.

As photographers searched for new images, they learned that many of these existed in a fresh view of

nature. Images that were inherently graphic, like fences, shutters, wiring diagrams, and a host of commonplace objects, became the subject matter for a new wave of photography.

In exploring action with their cameras, photographers like Edward Muybridge and Harold Edgerton opened viewers' eyes to previously invisible aspects of reality, and in the process, they created some startling graphic effects.

In another way experimental designer/photographers, like Man Ray and Moholy-Nagy, opened viewers' eyes to even more complex images by introducing a special form of lensless photography called photograms. Man Ray was also one of the first photographers to experiment with solarization and the Sabattier effect.

In addition to these experiments and inventions in photo/graphics, we are also indebted to the Russian Constructivists like El Lissitzky and the designers who followed their influence like Cassandre, Herbert Matter, and Paul Rand, for their contributions to the interaction of design and photography.

Line, texture, and tone

Most of the effects referred to in this section were stumbled upon by the pioneers of photography. From the beginning, tone was a major part of the photographic image; but the halftone dot, by which this image could actually be transferred to the printed page, was a late arrival. Texture was an ingredient that Fox Talbot had explored in the middle of the nineteenth century, when he used textile patterns in his search for a way to print halftones on a printing press; but probably the major introduction of texture is more accurately traced to the Man Ray experiments in Paris in the early 1920s (see pages 35-36). The

high-contrast technique that converted halftone images into line images probably came about by an overexposure in brilliant sunlight, an effect that casts deep shadows. High-contrast was also explored when methods were being sought to reproduce images before the halftone dot became available. Today, with many film and paper options available, high-contrast photography is frequently used as a design force, as the following pages dramatically demonstrate (see pages 50-55).

The technical methods of achieving photo/graphic effects is beyond the

province of this book, but it is useful for our purposes here to list a few of the principal methods of photographic manipulation that make these effects possible. These will be briefly identified and explained in the hope that they will give the reader a better understanding of the illustrations in this section and in section five.

Double exposure: This effect was once an unfortunate accident that marred the work of early photographers when they had failed to change the plate or advance the film. Today's fool-proof cameras make this form of double exposure

49

The variety of screens and the different ways they can be used in printing allow photographers a choice of textures and special effects.

impossible, a fact that makes deliberate double exposure even more difficult. Any in-camera method of double exposure is rarely used today, and for many years most double exposures have been handled in the darkroom, either by contact-printing separate negatives or with the help of the enlarger. However, there is still another way that this popular and effective technique is being practiced; it is a process known as *sandwiching*.

The sandwich: This form of superimposition came into being with the advent of the color transparency. It is a relatively simple matter for a perceptive photographer to plan the photography of two images that will go together to make one. This is a highly successful method of arriving at the double-exposure effect; and although similar to other forms of double exposure, the sandwich technique sometimes needs the help of a processing lab or retoucher. In recent years commercial photographers have returned to prints like the dye transfer and the Cibachrome to aid in the refinement problem of the final result. Several impressive examples of the sandwich technique are included in the color section in section five (see pages 84, 93, 94-95, 96).

The photogram: This form of lensless photography has already been referred to, but because it is such an important part of photo/graphic design, a review of it is not out of order. The photogram is one of the simplest processes; any light source will do, but the enlarger light, because of its superior control, is the one most commonly used. For subtle effects, the light source is often augmented by a flashlight or even the light of a match. Once you have a light source, all you need is a sheet of

The contemporary art photography of J. Seeley is based on high contrast. His use of lithographic film to capture the images on these pages (50-53) gives these photos the stark blacks and whites that resemble early prints made before development of the half-tone screen.

photographic paper on which to place the objects. Sometimes these objects are moved or removed during intermittent low-intensity exposures. Double and triple exposures are easy; in fact, the sky's the limit, but it's not a bad idea to have developer trays and test strips handy so that you can check the results in this essentially trial-and-error technique.

Solarization and the Sabattier effect:

Named after the Frenchman Armand Sabattier, who discovered the process, this technique can be used in both color and black and white. The Sabattier effect is relatively simple, but it is also often unpredictable and a fair amount of trial and error may be indicated. In this process a print is exposed with intensified contrast, and then, during development, it is exposed again in dim light. This results in a partly reversed image that is a unique blend of positive and negative. Sometimes this effect is achieved with a duplicate negative; you can produce the Sabattier effect by turning on the room light briefly while the duplicate negative is midway through development. Then, when the processing is complete, the enlarger is used for making your print.

Reticulation: This is one of the ways that a photographic image can be given a textural effect. It is achieved during processing by moving the film between hot and cold solutions, which tends to break the emulsion into a pattern. Like many of the other photo/graphic techniques, the reticulation technique can be used with both color and black-and-white material; but because it is for the most part unpredictable and irretrievable, it is often wiser to work with duplicate transparencies or negatives than with originals. Although it is possible to reticulate already processed film, it does require more soaking time, beginning with a 70° (21° C) water bath, which softens the emulsion and prepares it for processing. One of the advantages of working with processed film is that you can work in the light and see what you're doing. If the pattern isn't strong enough on the first try, you can run the film through the reticulating process again.

Posterization: As the name implies, this is a process developed to convert halftone film into broader patterns of flat tone, which can be used with either grays or colors and added with the use of filters. Posterization is particularly well-suited to silk-screen reproduction, although it is often used in other processes where a more dramatic or posterlike effect is desired. The technique calls for dividing a photograph into a few flat tones by making two or more high-contrast negatives. The original material can be color or black-and-white. Posterization has a unique advantage for the designer because he can creatively construct a color image out of a black-and-white subject or convert a color image to the color of his choice. It is one of the processes that brings the reality of

52

53

photographic images into harmony with the painters' art (see pages 102-103).

High-contrast: This technique is basic to many of the other photo/graphic effects mentioned in this section, including posterization as noted above. A high-contrast print with its pure tones of black and white definitely makes reproduction easier because in its pure form it converts a halftone image to line copy; and from a designer's and photographer's viewpoint, it has the advantage of being able to transform the original image into a more powerful statement (see pages 56-57).

Normal black-and-white photographic film and papers are panchromatic and continuous, and they translate the subject colors into balanced tones in the exposed image. Litho material, which was developed for lithographic reproduction, is orthochromatic and lacks the tonal fidelity of panchromatic. For that reason, lithographic film is generally considered superior for high-contrast results. Contrast can be enhanced in several ways when it is planned in advance. One way is by underexposing the photograph

54

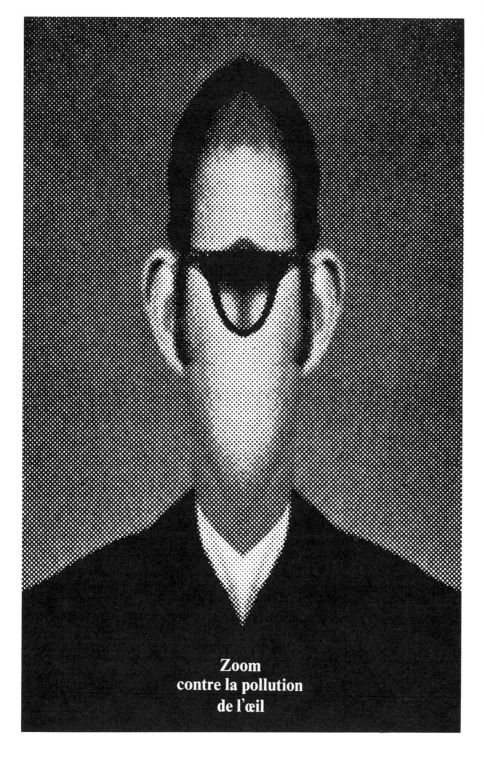

**Zoom
contre la pollution
de l'œil**

When the name Picasso falls upon the eye, a portrait of a legend comes to mind. It's the legend in the world of art which surrounds a man who possessed and expressed many of the highest ideals of mankind. The popular legend is of the outward attributes: seclusion and gregariousness; wealth and love; abundance of works and extraordinary versatility in all facets of his field. It has been estimated that Picasso created over fifty thousand works of art. Pablo Ruiz Picasso was born into a family of art, so he naturally had a very early beginning in his creations. His life was long, ninety-one years, but when we do the arithmetic we still find that he averaged throughout his creative years almost two pieces of art per day. Considering the physical size and the conceptual scope of many of his works, these numbers bespeak a remarkable feat. How is it that a man could be so one-pointed and inventive that he would become, as one author describes him, "the most prolific artist of all times?" Picasso's own words may reveal the answer: "Painting is stronger than I am; also, "painting makes me do what it wants." Another of the components of the popular legend is that of his departure from tradition. Picasso is known by many as having been instrumental in founding and energizing two new movements in art, cubism and surrealism; and to have inspired other movements including abstract art and pop art. His departure into cubism, which has become perhaps his best known realm, was met at the time with ridicule and contempt. The general attitude of those who saw this new trend was, at best, closer to endurement than to endearment. A very few had any awareness that in Picasso painting was giving birth to truly significant modes of seeing and expression. These few, and Picasso himself, might have argued that his seemingly radical forms were logical outcomes or extensions of the traditions of painting thus far, or at least, of the spirit of painting. That same unbounded energy of art that had explored so many obvious and subtle ways of seeing was, in this twentieth-century Spaniard, continuing its exploration. The world has indeed marveled that so much of that energy was concentrated through the eye-hand of this one man. Those who have known Picasso and have written of him begin to reveal the inner, mystical legend when they independently ascribe this superconductivity to his unceasing wonderment-a wonderment born of innocence and openness that had no need to look through the tinted glasses of dogma. Indeed, as his own cubist movement became intellectually structured and dogmatic, he left its mainstream. In doing this, he kept himself in the main evolutionary stream of art itself, which adheres to principles of a more general and interaccommodative nature. Picasso was thus free to draw upon the principles he had discovered in several specific modes of painting to achieve an even more comprehensive vision. One needs to be careful not to think that he mixed some of this style and some of that to achieve something new. His art grew from within and manifested itself in the appearance of mixture. He elaborated, "Art is not the application of a canon of beauty, but what the instinct and the brain can conceive independently of that canon. When you love a woman you don't take instruments to measure her body, you love her with your desires." His ability to create independently of the numerous canons of beauty was witnessed by Gertrude Stein, one of his earliest patrons, who said, "He alone among painters did not set himself the problem of expressing truths which all the world can see, but the truth which only he can see." This internal truth must have been operative when Picasso painted his well-known portrait of Gertrude Stein, for without something of an inner vision his reflections on the portrait would seem absolutely baffling. As the story goes, he made Miss Stein sit eighty times for the portrait, and then he wiped out her face and substituted a face with mask-like qualities. There were criticisms which he dismissed with "Everybody thinks that the portrait is not like her, but never mind, in the end she will look like the portrait." Such a statement might seem impertinent, but it is hard to question his integrity, for his commitment to his work was absolute. Every work was born of desire and in deep concentration. Every work was also born living its own life. A painting or sculpture or lithograph or whatever, would begin in impulse, in vague idea, in spirit. Then as art "made him do what it wanted" it would evolve through the brush of its creator. Each stroke and each picture was an end, a breathing universe itself. Picasso seldom signed his works and never named them. He also customarily refused to explain them. It is perceived that such acts might have put too definitive boundaries on the pieces, limiting the potential that continues to exist within them. A father gives his child his own autonomy, never acknowledging the moment he becomes adult and never saying to him this is the kind of person you are or that is the kind of influence you have, because the child may become much more or may be seen to be much more. For similar reasons, one hesitates to write of the legend of Pablo Picasso, i.e. for fear of severely limiting its fullness. Yet, even as the legend itself is found within the depths of the viewer's consciousness, so are these words found looking out of a piece of paper.

In this striking promotional piece for the French magazine Zoom (left), designer Roman Cieszlewics used a half-tone print to create this one-eyed image, then enlarged and reshot it as a "line" photo with lithographic film. Note the enlarged half-tone dots in the background. Paul Siemsen's typographic portrait of Pablo Picasso (above) uses different sizes of type instead of dots to register intensity.

in the camera and then to compensate by increasing the development time. When the original material is in color, special print film is necessary because the red/orange can cause trouble with lithographic material. Nearly all prints and film developed for the high-contrast process will need some spotting or opaquing. Sometimes a skilled designer or photographer can use opaquing creatively to modify the final image.

Other photo/graphic effects:
Although most of the commonly used techniques for photo/graphic effects are covered above, there are a few others that are worthy of mention. The *bas-relief* effect is used to create a three-dimensional illusion. It is arrived at by making a contact positive from a high-contrast negative, binding the two together slightly out of register, and printing from the combination.

Grain is a natural effect of extremely high-speed film, but it can also be enhanced by darkroom procedures. Underexposure of the film and a stepped-up development time can increase the density of the grain as well as the contrast. Grain size can be increased by too much exposure or excessive agitation in development. In the 1960s the exaggeration of grain became a fad among designers and photographers, but since then its popularity has faded. A *moiré pattern* is a phenomenon that occurs when two screens are placed over an image at different angles to each other. This effect is sometimes achieved accidentally. The moiré pattern happens when a screened halftone reproduction is photographed through another halftone screen, but the effect can sometimes be eliminated by changing the angle of the screen.

The designer Cassandre was

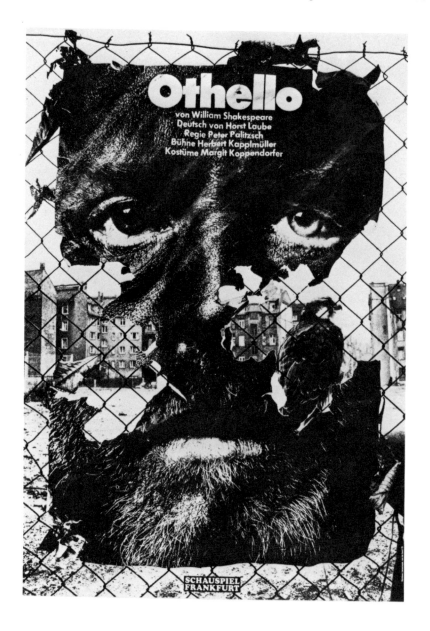

Double exposure is what
makes these posters by
the design team of G.
Rambow, G. Lienemeyer,
and M. van de Sand so
eye-catching. Far left, a
display for a Frankfurt
production of Othello. Left,
a brilliantly retouched
poster for a German
publisher.

probably the first person to explore the textural effects of the *enlarged halftone dot* (see page 53). Since then, many other designers have used the dot pattern and its revealed image as an effective technique of photo/graphics (see page 58). Another approach that has been effective in photo/graphics is *distortion,* which can be arrived at by unusual camera angles and special camera lenses. Distortion effects can also be achieved with the enlarger by using special lenses or angled or curled photographic paper. It can also be arrived at by using special material such as hammered glass, to distort the image. Still another form of distortion is created when a zoom lens is put in motion during a photographic exposure, which can produce a radiating impression of the picture, as the football action demonstrates on page 63.

The techniques reviewed in this section have been shown in their application in photographs, but these techniques have an even broader use in design and illustration. Fred Otnes is an artist who has applied many of these camera-based techniques to drawn illustration (see page 59). His images are essentially collages, but they evolved from the photographic-printing-lithographic technology with which he became familiar. Otnes combines film negatives with acetate positives, which permits an unlimited amount of experimentation with the arrangement. He uses both superimposition and juxtaposition to create a unique, provocative, and highly personal art form.

Summary: The preceding pages have reviewed nearly a dozen different approaches to the technique of photo/graphic design. These can be used singly or in combination. All of these processes

58

59

Artist Fred Otnes brings a variety of camera techniques—high contrast, reticulation, sandwiching—to his work and uses photos in layers to create collages.

bear a relationship to the three basic divisions that head this section: line, texture, and tone. In the brief summary that follows, the various techniques will be presented in their proper relationship to these photo/graphic categories.

Line: The most obvious and most important technique in line photography is the *high-contrast* print, which reduces the halftone values of a photograph to pure black and white. A near-perfect example of this is shown in the illustrations by J. Seeley (see pages 50-53). Two other approaches to line conversion are *posterization,* which creates its own color separations through high-contrast prints and masking; and *bas-relief,* where a negative is printed in combination with a positive to create a three-dimensional effect.

Texture: This effect is usually arrived at by adding an already existing pattern to an image through double exposure or superimposition. Man Ray introduced it into his photograms in the 1920s when he wanted to add interest to his backgrounds (see page 35), and it has been incorporated into photography many times since then. Sometimes in the *solarization* process, textural effects will grow out of the negative and positive conversions, but a more consistent result can be achieved by a process called *reticulation,* a process in which heat and cold can break up the emulsion surface during development. From the time of Cassandre the textural quality of the *enlarged halftone dot* has performed a major role in photo/graphics (see pages 54 and 45). Other textural effects that can be created by the photographer or darkroom technician are exaggerated *grain* and the sometimes troublesome *moiré pattern.*

Tone: The modern halftone has long been refined to the point that any evidence of its textural quality has vanished. Today the gray scale of a reproduction can often match that of the original, and even color reproduction leaves no visible evidence of its screened origin. Many contemporary examples of photo/graphics use tonal values to gain sophisticated results. The *double or multiple exposure,* whether it is arrived at in the darkroom, camera, or by collage, is a case in point. Superimposition, which is similar to double exposure but arrived at by placing two transparencies together in a *sandwich* format, also takes advantage of tone.

A form of photo/graphics that can exist in all categories is *distortion.* This affect can be achieved in several ways: by camera angles, with special lenses that break up images, by manipulating the printing surface in the darkroom, or by introducing special surfaces, like hammered glass, to the printing process. Distortion is often used in combination with line tone or textural effects.

These pages have attempted to make it clear that photo/graphic design is a process that invites creative effort but calls for control and discipline to avoid the pitfalls of the banal and the overdesigned.

Image on the page

When William Henry Fox Talbot invented the negative and positive technique of photographic reproduction and opened the door to mass printing, the printed page could hardly wait for the technical developments that would make this large-scale reproduction feasible. Fox Talbot had already observed that it was essential to break up an image into short lines or dots in order to reproduce the full tonal range of a photograph; he had even demonstrated the halftone principle in a series of experiments using textile as his screen. But the halftone screen as we know it didn't come into being until the end of the nineteenth century. The reproduction of photographic images preceded this event in a number of ways. First, aquatints were made by copying the original photographic prints, and sometime later, engravers in wood or steel made some impressive copies of photographs for publication in magazines like *Harpers*.

In spite of these early efforts to transfer the photographic image to the printed page, effective reproduction and the final formation of the modern magazine was to be delayed until the first quarter of the twentieth century. There were two major forces that contributed to the development of the modern magazine. One was primarily concerned with the photographic aspect; the other was based on a new concept of the shape and form of the page itself.

The origins of modern magazine design: The initial photographic force of the modern magazine was formed around a group of German and Hungarian photographers led by Erich Salomon and a group of camera designers led by Oskar Barnack. Salomon was the first photographer to comprehend the full potential of the fast lens and the

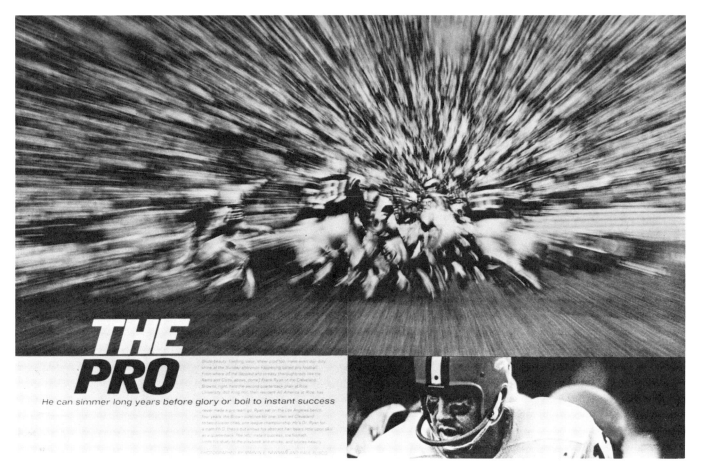

The zoom lens adds drama and movement to this football action photo, allowing photographer Marvin Newman to change focal length while making the exposure.

freedom from the confines of flash powder and time exposure. His photographic studies of political figures in Berlin during the 1920s using only available light were the first to be described as "candid." With these photographs Salomon had opened a door through which were to pass such eminent photographic pioneers as Brassaï, Kertész, and Cartier-Bresson. These Salomon photographs also provided the foundation for photojournalism and the picture magazines that were to have their beginnings in a printing shop called Ullstein in Germany.

The other founding force of the modern magazine can be found in the revolutionary approach to page design of the Russian Constructivist designers during the same period. Influenced by the Cubist experiments in Paris, the new freedom that the Dada typographers brought to page design, and the asymmetrical forms that may have some relationship to Russia's proximity to the Far East and the Orient, Russian designers like El Lissitzky and Alexander Rodchenko were suggesting new directions for page design.

One phenomenon of this graphic revolution that has few ties to the European-Constructivist design revolution is the Russian influence on America. Two designers, who were born in pre-Constructivist Russia and came to America in the late 1920s, share the responsibility for the development of the modern magazine in America. If they were influenced by the ideas of Constructivist design, it was probably channeled through Paris where they both spent some time and where they both came under the influence of the new ideas that were taking form on the continent. One of these designers was Alexey Brodovitch, whose designs for *Harper's Bazaar* and the original *Portfolio* and extensive teaching experience were to exercise such

The asymmetrical division of space, as employed by modern designers, owes much to Japanese form and its basic module—the tatami. The double-square proportions of this traditional straw mat are used in various combinations, like the six-tatami pattern (below right). They are reflected in Paul Fusco's photo (right) and give it a form as identifiably Japanese as its subject.

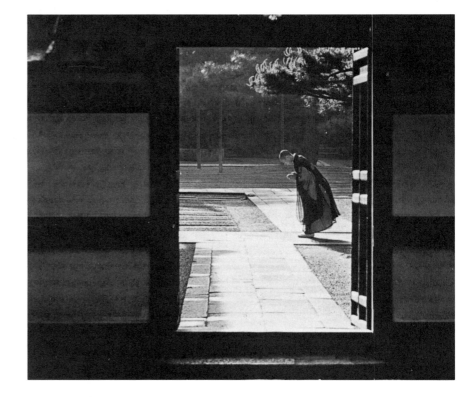

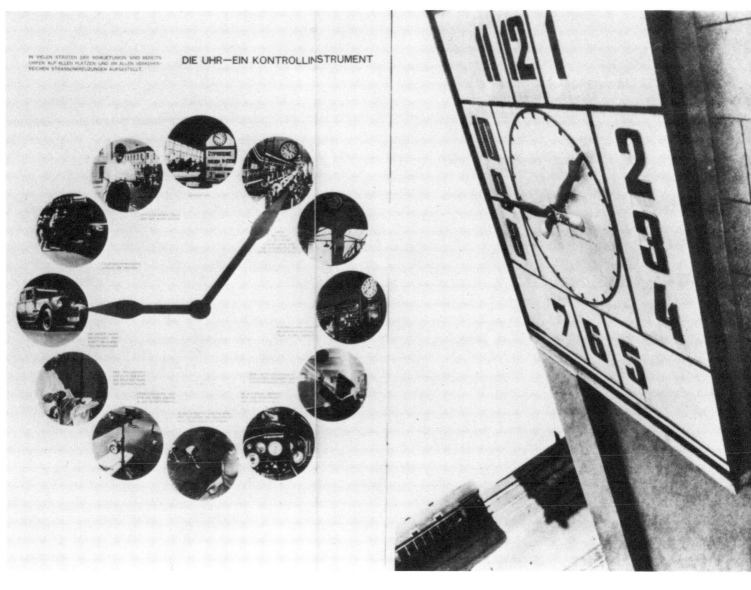

Designer Nikolaj Trasjin took a constructivist approach in this layout to demonstrate both the nature and the various aspects of clocks as instruments of control.

66

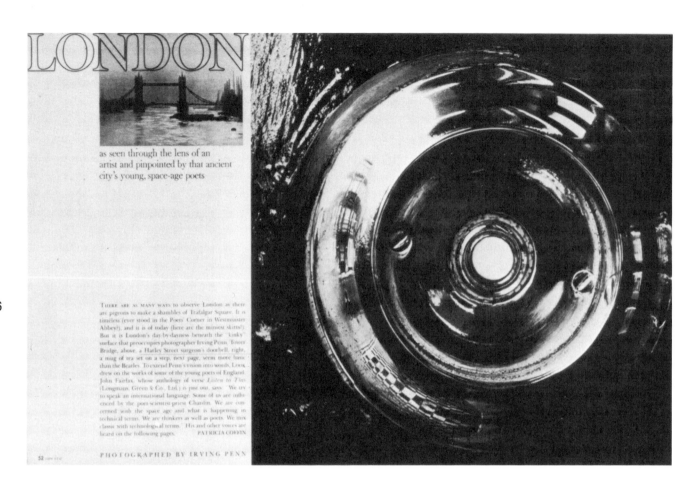

LONDON

as seen through the lens of an
artist and pinpointed by that ancient
city's young, space-age poets

THERE ARE AS MANY WAYS to observe London as there
are pigeons to make a shambles of Trafalgar Square. It is
timeless (ever stood in the Poets' Corner in Westminster
Abbey?), and it is of today (here are the miniest skirts!).
But it is London's day-by-dayness beneath the "kinky"
surface that preoccupies photographer Irving Penn. Tower
Bridge, above, a Harley Street surgeon's doorbell, right,
a mug of tea set on a step, next page, seem more basic
than the Beatles. To extend Penn's vision into words, Look
drew on the works of some of the young poets of England.
John Fairfax, whose anthology of verse *Listen to This*
(Longman, Green & Co., Ltd.) is just out, says: "We try
to speak an international language. Some of us are influ-
enced by the poet-scientist-priest Chardin. We are con-
cerned with the space age and what is happening in
technical terms. We are thinkers as well as poets. We mix
classic with technological terms." His and other voices are
heard on the following pages. PATRICIA COFFIN

52 LOOK 7-6-66

PHOTOGRAPHED BY IRVING PENN

This Look *magazine spread uses
contrast of scale to heighten the
impact of Irving Penn's pictures. A
small image of a large object plays
against a larger-than-life image of a
small one.*

an influence on the form of the modern magazine. The other designer was Dr. M. F. Agha who became art director of the original *Vanity Fair* magazine in 1929 and of *Vogue* magazine one year later, both of which were models of sound design.

The combined work of both these designers laid the foundation for the development of a group of American magazines that culminated in the 1960s when magazines like *Esquire, McCall's,*

Life, and *Look* reached their zenith and began to exercise that world-wide influence that formed the essential background for today's magazine design.

This section of the book concentrates on the interaction of the photographic and design forces as they come together to form the printed page. In examining the process of page design, I will attempt to sift out some of the basic principles that have contributed to successful page design. The

designs I have used here for demonstration purposes are mainly from *Look* magazine, and while some readers may find a few of them dated, they are important because they reflect many design considerations that are relatively unchanging and universal. There is also an advantage in clearly understanding my own motivations and design intentions, which might be an extremely difficult process with randomly selected samples.

Because design is a complex

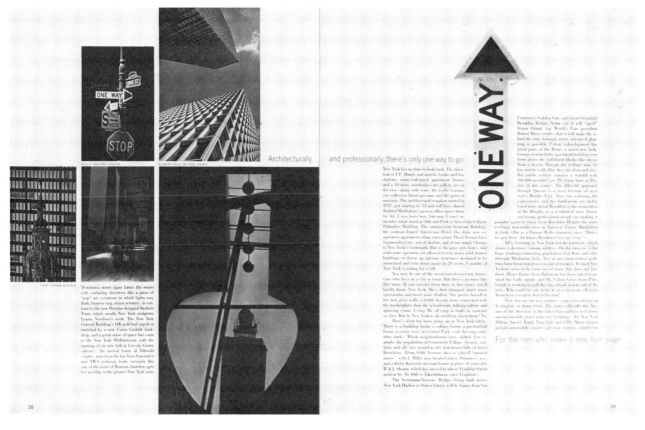

Design, though static, can indicate specific movement. In this layout, the direction of movement is up and made most obvious by using a normally horizontal one-way sign vertically to indicate New York City's upward thrust.

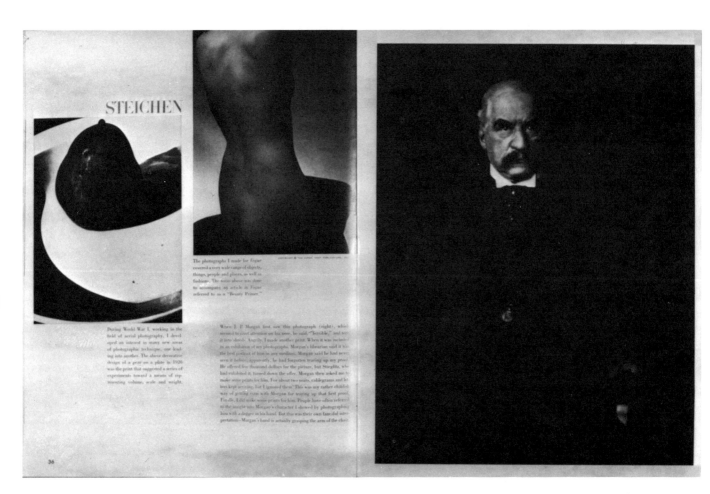

68

36

Contrast of values can be seen
most clearly in stark black and
white and give designs like this
layout of Edward Steichen classics
(above) a power rarely seen in four
colors. The spread for Bert Stern's
"The Trouble with Being Beautiful"
(right) uses contrasting scale as
well as contrasting values.

combination of many forces and often arrived at by an intuitive process, it tends to defy scientific analysis and the application of formulas. Nor is page design a simple sequential problem that can be spelled-out in a step-by-step progression. For these reasons the following study must be approached with some caution; but if the reader takes a balanced view toward the content, he or she may gain an insight into the intricacies of page design.

Picture selection: Probably the most important factor in the selection of pictures for a layout is their content.

Does the image accurately portray the editorial intention? The designer shouldn't lose sight of the fact that in the search for a logical solution there may be a tendency to settle for the obvious and the bland where a less predictable choice might add an important element of surprise. Alexey Brodovitch repeatedly admonished his students with the demand, "Surprise me!" and for many of his students this became the key to excellence.

Skilled photographers working on an assignment will often start the process of selection even before the first exposure has been made.

They will have studied the nature of the problem and explored its physical requirements so that they can apply their creative talent at the earliest possible moment. Rarely will a successful visual treatment develop out of random shooting. There have been many times when photographers have arrived at the doorstep loaded down with trays of exposed film but without the slightest notion of which pictures are the right ones. There have been other times when a skilled photographer has hewed-down his selection to the point that the designer has so few choices to make that a meaningful layout may

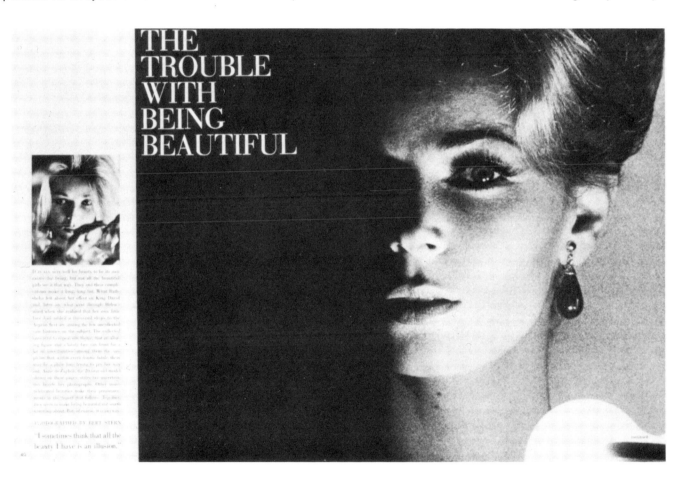

be impossible. In the end, each photographer will have to work out his own approach to picture selection; but it is a matter that should be freely discussed with the art director and should take into account the editorial needs of the assignment.

One of the things I have learned from working with hundreds of photographers is how experience can sometimes influence judgment. A photographer taking a picture is often so involved with the action during the taking that he finds a quality of believability in the result that may not be evident to the viewer encountering the image for the first time on a page layout. One of the virtues of a good art director is his ability to bring this detached judgment to bear in the matter of picture selection. It is also one of the reasons for frequent misunderstandings between photographers and designers.

In selecting a picture, the art director should never lose sight of the image's relationship to other images that may appear on the same spread or within the context of the total layout. Sometimes it is possible to go through the collected exposures available to a given layout and almost instinctively find the half-dozen or so that will make up the completed essay. On other occasions, the search may be long and tedious, with some side excursions into trial-and-error designs. In any event, it will help the designer as well as the photographer if he has a genuine understanding of the editorial direction and if he has a visual concept in which to develop a framework for the design. As the process moves from picture selection to page layout, the designer enters the complex realm where space, form, and juxta-position take on a new importance.

A successful layout moves the eye
along an obvious pathway. At left,
the path spirals up and around,
from the smallest image to the
largest. Above, the design moves
straight up. The flagpoles and the
tight bleed of the type (a risky
device that does not always work
this well) lead the eye off the top of
the page.

72

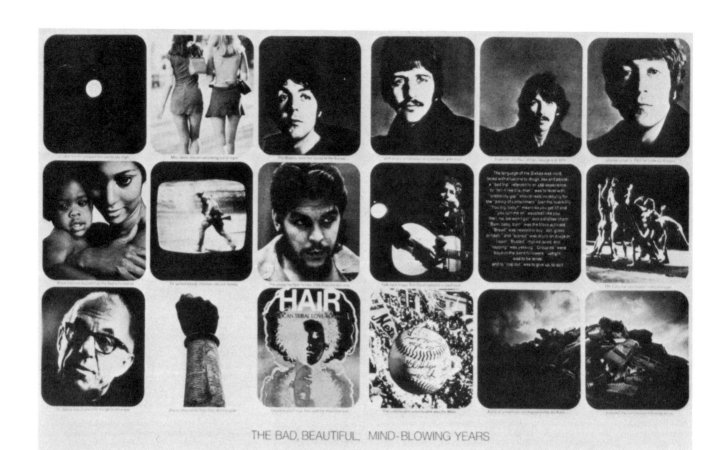

THE BAD, BEAUTIFUL, MIND-BLOWING YEARS

A variety of photographic styles and techniques illustrate a single theme in this spread from the Look magazine package "The Sixties." Unity is achieved by consistency of the design elements.

Contrast of size: Selecting the size of a given image is at the root of the page design process. When two images are placed in the same visual plane, their impact can be enhanced by a difference of size. The large image will add emphasis to the size of the small image and may make it seem more important. On the other hand, the small image will make the large image still larger and even more dynamic than it would be without the contrast. Obvious as this point of size contrast is, it is still amazing to me how often I come across dull layouts that are guilty of a bland uniformity of image sizes.

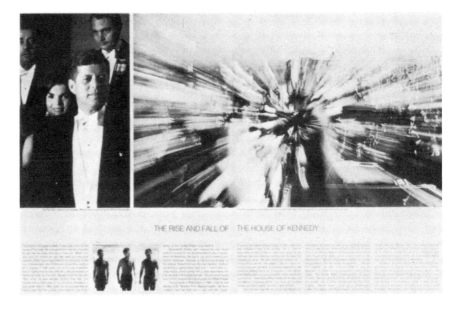

THE RISE AND FALL OF THE HOUSE OF KENNEDY

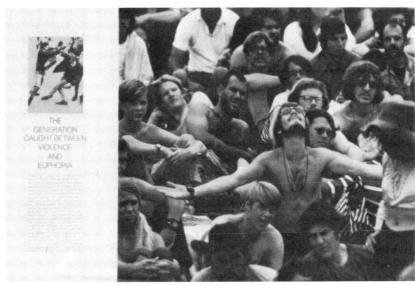

THE
GENERATION
CAUGHT BETWEEN
VIOLENCE
AND
EUPHORIA

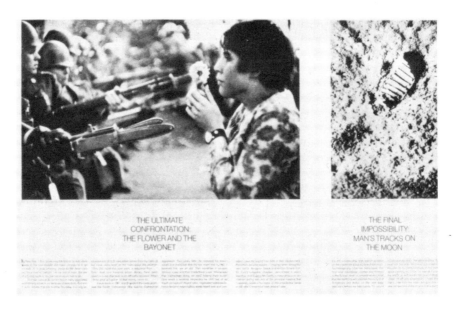

THE ULTIMATE
CONFRONTATION:
THE FLOWER AND THE
BAYONET

THE FINAL
IMPOSSIBILITY:
MAN'S TRACKS ON
THE MOON

Contrast of value: The white of the paper and the black of the ink are polar forces in the design process. When an image containing large areas of blackness is placed against a high-key image, the resulting contrast can have a positive effect for both images and increase the visual impact of a design. Value contrast also applies to images in color. Muted tones can be played against tones that are highly saturated in color; cool colors can be contrasted with warm colors. The juxtaposition of complementary or even discordant colors can create chromatic contrast and serve as a positive force in page design.

Contrast of shape: Unlike many photographers who are often locked into the form and proportion of their viewfinders, most of us tend to see our world through a tremendous variety of shapes. An image may be glimpsed through a partially opened door, a window with a shade partly drawn, an angled opening, or even a free form. Our cognitive vision may help us to see a figure as a detached silhouette. In applying this kind of freedom to picture cropping, the designer should avoid destroying the original quality of the photograph.

Contrast of mood: There is still one other form of contrast that can sometimes add to the effectiveness of page design. When two pictures of contrasting mood are juxtaposed, their emotional impact is increased. Because this form of contrast is concerned with the emotional response of the reader, the designer should use it with considerable care. On the other hand, such contrasts as violence and calmness, sorrow and joy, and youth and age can often have a positive effect on visual impact.

74

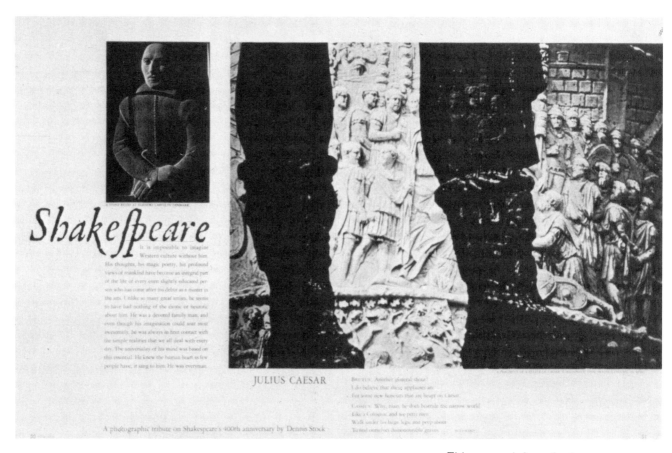

This spread, for a feature celebrating the four-hundredth anniversary of Shakespeare's birth, is based on a camera-cropped photo by Dennis Stock. Using a long lens to bring a statue's legs up against a Roman crowd sculpted in relief, he captures Cassius's words about Caesar: "Why, man, he doth bestride this narrow world like a Colossus."

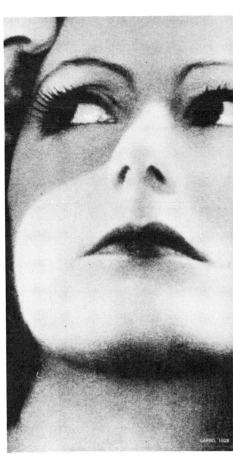

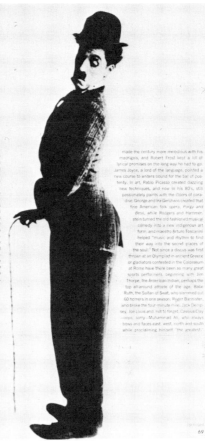

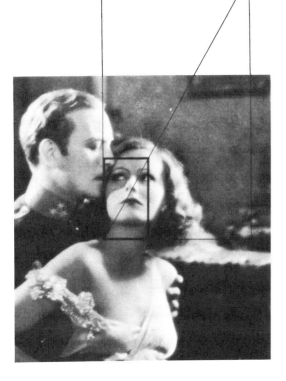

Imaginative cropping, as well as picture selection, gives strength to "Faces of Pleasure" from a feature on the first half of the twentieth century in Look *magazine. A new image of Garbo (left) was discovered in the larger photo below; its freshness is enhanced by the extreme enlargement.*

Format and style: Even a casual study of a magazine will reveal that a single issue is much more than a series of well-designed spreads held together by a binding. Effective page design calls for a harmonious continuity of editorial units extending from cover to cover. This cover-to-cover unity should extend to an overall style from issue to issue until the personality of the publication is revealed. This sense of style and continuity should grow naturally out of both the editorial objectives and design considerations of a given magazine, with the principal emphasis on editorial and communicating ideas.

76

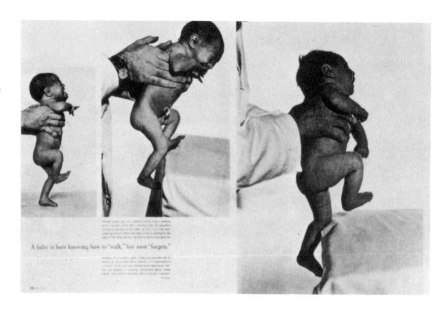

Only a minimum of cropping was needed to increase progressively the size of the images, emphasizing action within the photos and overall movement in this layout for "The First Weeks of Life."

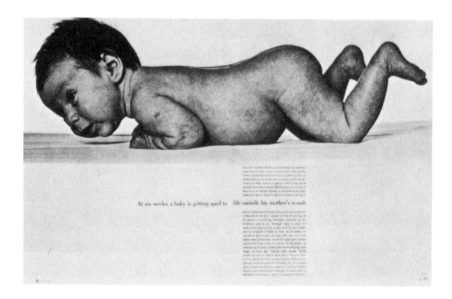

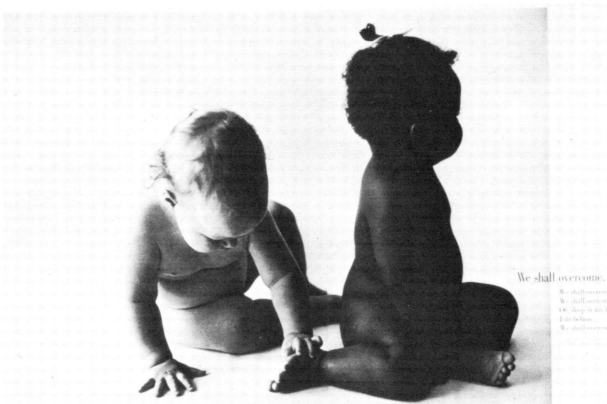

We shall overcome.

We shall overcome.
We shall overcome someday.
Oh, deep in my heart,
I do believe
We shall overcome someday.

This photo, one of 700 exposures photographer Art Kane made to illustrate "We Shall Overcome" for "Songs of Freedom" in Look, truly caught a "decisive moment." When we briefly believed the transparency had been lost, I went through the remaining 699 and found none could replace it.

A strongly welded format that makes for an enduring impression on its audience requires a close understanding and working relationship between editor and art director. In exploring magazine history, it is not difficult to discover a long tradition backing up the importance of this kind of cooperation; and perhaps the best advice that can be given to a young art director is to find a great editor. Since this is not an easy task, a sounder suggestion would be to suggest that the designer make a better effort to understand the needs and aspirations of the editor that he has.

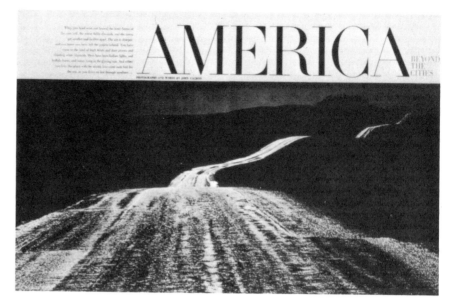

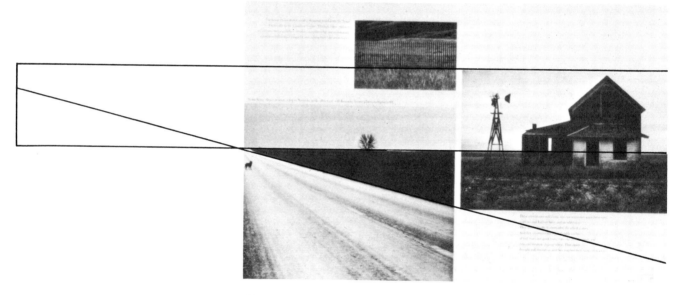

Perspective moves the reader's eye across this spread and ties together images from "Heartland of America" (above). John Vachon's photos had to be selectively cropped in order to make this design work. At right, note how the series of photos on the left side have been cropped so that the wing struts of the airplane form a straight line. These small images are played against a larger image that appears much as photographer Douglas Kirkland saw it in his viewfinder. Below right, the shape Ernst Haas gave his photo of Stonehenge establishes horizontal lines, which is picked up in the type beneath it.

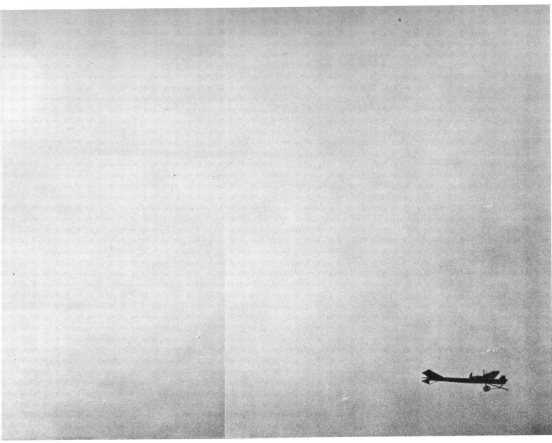

PHOTOGRAPHED BY ERNST HAAS

SPRING

Englishmen treasure their spring. "It warms the world anew," said Algernon Charles Swinburne. James Thomson wrote, "Fair-handed Spring unbosoms every grace," and Robert Browning longed to be in England "now that April's there." Winter is a long, dark, narrow, chilling experience for the English. But in February, crocuses begin to bloom in the

COMES
TO ENGLAND

Scilly Isles. The season marches slowly north, through Cornwall, past Salisbury Plain (above), past London and into the Midlands. Now, once again, the land shakes itself alive. Spring, in the words of Shakespeare, "hath put a spirit of youth in everything."

Summary: When we examine the design process, it is not difficult to think of it as a series of steps. In reality, design is more likely to be a conditioned response in which the space, the pictorial considerations, typographic needs, and relationship of images to each other are all brought together into a single action. A skilled designer can sometimes construct a multiple page layout in his mind with only a casual glance at the assembled material. For the most part, however, the solutions are not that simple, and a tedious search for the often illusive design is necessary.

80 Once the pattern for modern magazine photography had been laid down by the pioneers of candid photography, and the design of space had been set free by the Dada experiments and the Constructivist designers, certain principles governing visual communication and the printed page began to emerge. When the designer selects pictures for his layout, the primary concern is with content and its relation to editorial objectives; but there are times when too logical an approach leads to blandness and denies the layout the attention-getting value of surprise.

When pictures have been selected, or even before they are selected, the designer will be concerned with the juxtaposition of images. Whether the layout has two or more images, their relationship is critical to the success of the design. One of the principal elements in the successful combination of pictures is contrast. The contrast of *size* (large against small); of *value* (dark against light); of *shape* (horizontal or vertical, narrow or wide); or of *mood* (joyful or sad) can all add to the impact and meaning of a visual presentation.

Finally, in the search for harmony between images, the designer will sometimes find lines or parallels

within the images that will reinforce their relationship and help to achieve a cohesion and unity within the design. The successful designer will also see that this harmony extends to his working relationship with photographers and with his editor, so that, together, they can bring uniformity and style to the magazine's format.

Color into design

5

The earliest attempts at color photography were aimed at authentic reproduction. The precise rendering of a still life or textile pattern was often more important than the picture as a whole, and design considerations had a low priority. But as new faster and more flexible films and improved cameras came onto the photographic scene and competition and concept began to influence photographers, designers began to pay more attention to special effects that would make their images outstanding.

Perhaps the first workable color system was invented in Paris in 1891 by Gabriel Lippmann. The system was described by Steichen as "simply dazzling, and one would have to go to a good Renoir to find its equal in color luminosity." Unfortunately, flaws in the Lippmann system doomed it to oblivion. Steichen was one of the first photographers of note to experiment with color, and he exhibited several *autochromes* in 1907, five years after it was invented by the Lumière brothers in France. These early probes into color photography were based on the *additive* color system, which combined the photographic primary colors—red, green, and blue—to form white.

These additive approaches were soon replaced by experiments based on the *subtractive* theory. This approach used the complementary colors of the additive system: cyan, yellow, and magenta. When light from these colors is combined, it creates black. This is the method most closely identified with the process-color system of reproduction, although a black filter is usually added to give better detail and resolution in the proof. The switch to the subtractive color system led to the invention of

the tri-color camera, which divided the light from a single source through colored filters to three different black-and-white negatives. Each of these plates could then be printed as a *dye transfer* or *carbro print,* or the negatives could go directly into the formation of engravings for the printing process. The tri-color camera produced some remarkable results, but it was awkward to use and the search continued for a system that would combine all of the primaries on a single surface.

The breakthrough came in 1935, when Leopold Mannes and Leopold Godowsky, in collaboration with the Eastman Kodak Company, found a solution in their formula for the Kodachrome process. From this invention came the development of Ansco-Color, Ektachrome, and virtually all transparency-based film. The next step in film development was the print film that returned to the negative and positive process. It became the principal film for amateur photography, although most professional photography still relies on transparencies because of a general superiority in resolution and a more precise reading of the results of the exposure.

When photographers work with transparencies, some of the darkroom control they have in the negative-positive approach is lost, because the more complex processing can sometimes demand professional laboratories. This means that some of the photo/graphic effects must be worked out in the camera itself or with the aid of elaborate conversions to dye transfer prints and retouching.

Color control and filters: One important method of color control and manipulation is achieved through the use of colored filters. In

84

For greater contrast and saturation, photographer Pete Turner, a master of color control, employs color filters and duplicate transparencies. Results are apparant in the richness of the dyer's hand (page 83) and the golden Buddha (right). Above, Turner combines elements from different transparencies, building an image in his camera of the moon flanked by space vehicles.

his photographs for *Life* magazine, Eliot Elisofon was one of the first color photographers to experiment with this technique. At one time he was made a consultant to a Hollywood film company where he was able to apply his color conversion to the making of the motion picture *Moulin Rouge.*

A contemporary photographer who is a master of color control is Pete Turner. As the images on these pages illustrate, there is probably no photographer taking pictures today who has a keener sense of color effect or a greater skill with the application of color filters to enhance a photographic result than

does Turner (see pages 83-85).

Color solarization: On rare occasions a single photographic assignment can involve many graphic techniques and cover nearly the whole range of photo/graphics. Such an assignment was the series of widely acclaimed portraits of the Beatles created by Richard Avedon for a 1968 issue of *Look* magazine.

As design director of Cowles Communications, I was responsible for the original concept of a special *Look* magazine issue on the "Sound and Fury in the Arts." The issue was to reflect the creative turmoil of the

1960s, and I was able to persuade Avedon to take on this assignment several months before the images were scheduled to appear on the pages of *Look.*

The talking phase began at once. There were discussions at lunch, over drinks, and in the viewing room with Avedon and Pat Coffin, the project editor. Scores of ideas were discussed, but as so often happens, there was no way we could visualize what the final result would be. In recalling the early planning, Avedon had this to say about the project: "We thought it would be interesting to reflect much of what was happening in

86

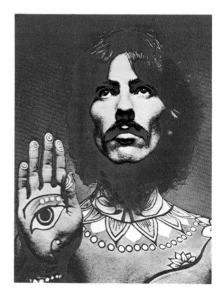

Richard Avedon's Beatles portraits were made for a special Look *issue, "Sound and Fury in the Arts." These powerful images resulted from a series of experiments that raised devices like body paint and op-art glasses from gimmicks to art.*

contemporary life, especially with the younger generation represented by the Beatles, who brought about a revolution in visual thinking: The art nouveau experience, op art, Eastern influence, painted bodies. These and many other elements were what we wanted to get into the pictures. I went to England with this concept in mind, but without a specific idea of how to carry it out."

During the few hours he had available for the photographic sittings in the London studio, Avedon photographed the four Beatles in both color and black and white. He used props and costumes. Make-up was applied to

underscore their individual and collective style: op-art glasses for John Lennon, body paint for George Harrison, flowers for Paul McCartney, and a dove for Ringo Starr.

Commenting on the results of the sittings, Avedon recalls, "What I came back with was not what I consider very interesting photography. It included some rather gimmicky ideas and a few series portraits. The pleasure of the sittings was in finding out how much the Beatles had grown in stature. Now they were truly interesting subjects with marvelous faces and a new spirit of cooperation."

On his return to New York, Avedon made an early decision to abandon the color exposures and work exclusively with the black-and-white negatives to create the eventual color results. These photographs, taken in the square format on 120 film, had been side-lit with a single electronic flash for maximum contrast. Once the selection had been made, the long cycle of experimentation began. As is so often the case in this approach to creative photography, the final direction was not clear until several experimental exposures had been attempted and, in most cases, abandoned. Early on Avedon

87

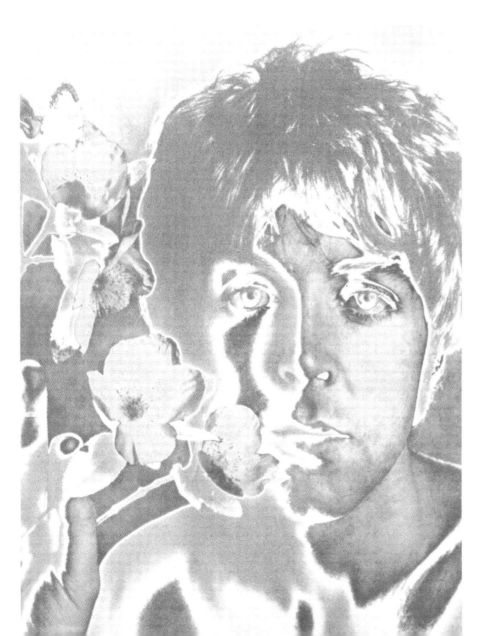

Abandoning his color exposures, Avedon decided to work with black-and-white images, like these of John Lennon, on a square-format 120 mm film, side-lit by electronic flash for maximum contrast. The enlarged shot (right) was the one Avedon finally chose to use.

recognized the hit-or-miss aspects of his approach and his need for technical assistance.

The early experiments with the Beatle portraits went through two distinct stages. The first stage began with high-contrast prints of the negatives, which were then combined with color filters and projected on Ektachrome sheet film to produce a color transparency. During this first set of experiments, Avedon worked closely with his assistant, Gideon Lewin. Together they tried many different filters and variations in exposure, but in the end it was clear to Avedon that the resulting images were far too bland for the result he was seeking (see page 86).

For the second phase of the experiment, Avedon and Lewin continued working with Ektachrome film, but later moved on to include both solarization and the Sabattier effect. This combination created a partial reversal of the tones in their color transparencies, an effect which happens when the undeveloped image or developing image has been briefly flashed with light. It was at this stage that some of the novel and exciting effects began to make themselves manifest as the reversal of color as well as value began to modify the image on the transparency. During this phase of the processing, Gideon Lewin became very skilled at controlling the brief flashes of white and colored light; but the results remained somewhat unpredictable, and it became clear that some form of better control was needed.

At this point, Avedon decided to move from the Ektachrome transparencies to the dye-transfer print process to achieve the kind of control he needed. As was pointed out in part three of this book, the dye-transfer process is one of the

oldest in color photography and was originally developed for the tri-color camera. This process, in which three separate negatives are shot through filters to capture the correct color values for cyan, yellow, and magenta, was ideally suited for the kind of shift from black-and-white negatives to color images that Avedon was after in his experiments. Here, he was able to project his modified black-and-white portraits onto a paper that would convert them to the color he wanted.

Unfortunately, dye-transfer is time-consuming, and it is difficult to find skilled technicians with enough experience in its application. Avedon had previously worked with Bob Bishop, who is head of a large photography laboratory, on photographic assignments that needed dye-transfers. Together they began a new level of experiments, in which they found it possible to change color at will and to strip different elements together. Their new approach also made it possible to retouch the dye-transfer in order to overcome unwanted accidental effects. Bishop even was able to devise special dyes that gave Avedon the intense psychedelic color effects he was after. Later on, when the printers became involved in the reproduction of these images on the pages of *Look,* special inks were used to make the reproduction as consistent as possible with the color modifications that had been introduced in the dye-transfer prints.

The pictures reproduced on these pages without the benefit of special inks can only suggest the variety of effects in this trial-and-error search for the final exciting results. Each of the subjects created a different series of problems as Avedon searched for a style that would

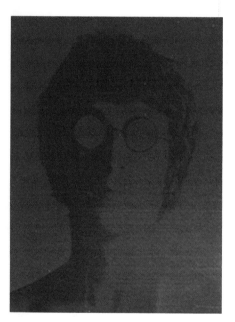 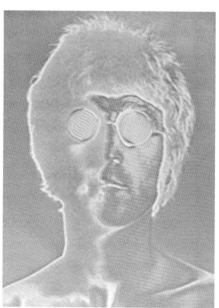 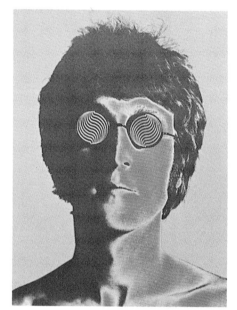

Simply projecting the black-and-white exposures onto Ektachrome film, using color filters, produced images too bland for Avedon, who next turned to solarization and the Sabattier effect to achieve a partial reversal of tones in the color transparencies. To gain more control over the results, he then abandoned color film in favor of dye-transfer prints.

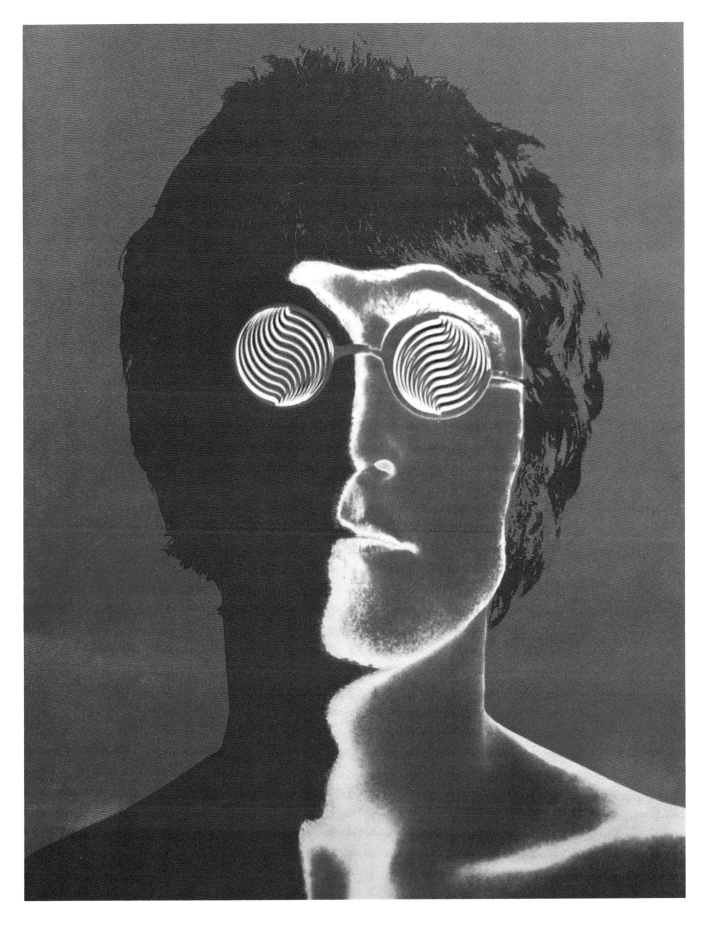

express each individual personality and still retain the balance that would make each image part of a cohesive set. The development of these images followed the same basic procedure, moving from high-contrast, black-and-white negatives to a color conversion on Ektachrome sheet film, with colors introduced by filters and modified by solarization. Each color image was then reinforced and refined as it was transferred to dye-transfer prints and smoothed out with a final gloss of expert retouching.

In summing up the results, Avedon commented that, "It didn't come easily. Actually, there is nothing new in any of the techniques we used, although I think we worked out some refined ways of using them. The challenge and the creativity came in applying them to reach the goal we had in mind."

Looking back on the piles of experimental Ektachromes, test-color prints, rejects, and revisions and then trying to get a measure of Avedon's time and the time of the technicians and retouchers, one might wonder if all of that expenditure of resources and energy was worthwhile. But when we look at the results—a magazine cover that sold far above circulation-department forecasts; a ten-page editorial feature including an unprecedented double gatefold; two Art Directors Club awards including the Gold Medal; and a worldwide sale of nearly a million posters—we begin to understand the dimension of this landmark application of photo/graphic design.

Since this feature appeared more than a decade ago, the techniques pioneered by Avedon have been widely imitated. Unfortunately, more of these efforts turned out to be demonstrations of the excesses of

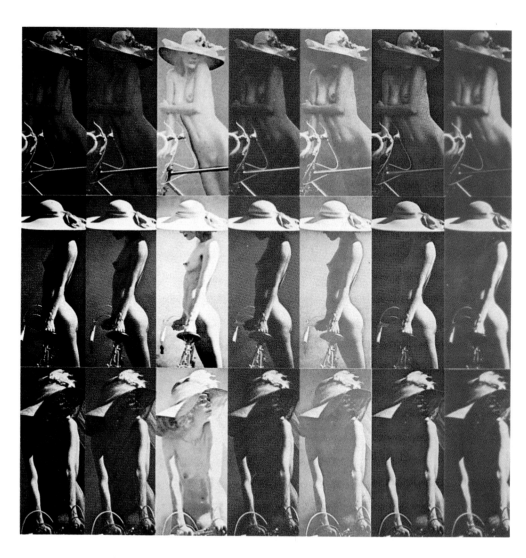

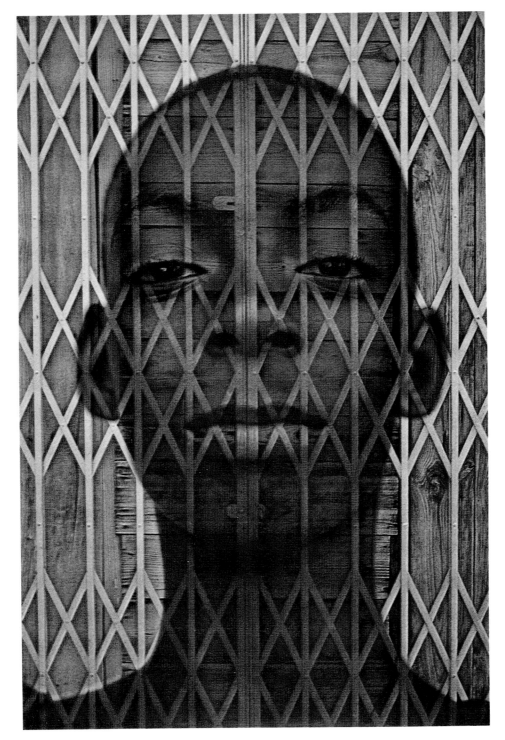

To create this startling composite,
(left), using three original images,
photographer Art Kane varied the
four-color printing process,
subtracting one or more colors from
each series. In the illustration for
"Songs of Freedom" (above), he
uses a sandwich to show a young
black man against the metal grill of
a warehouse.

the technique rather than its virtues; but they all add up to a tribute to Richard Avedon's genius for creative photography and his understanding of design restraint that made these portraits not only outstanding, but enduring as well.

Superimposing by sandwiching: Many contemporary photographers have been intrigued by the way in which two color transparencies can be placed on top of each other to create a new image of abstract or surreal proportion. The result is somewhat similar to the double exposure, but unlike that method the images can be taken apart and restored to their original form. The final effects can be seen

94

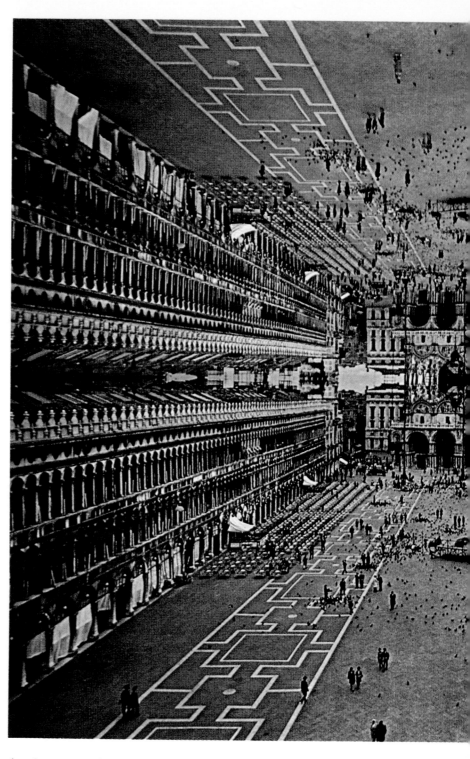

An elegant sandwich indeed is Art Kane's double view of Venice with one image of the Piazza di San Marco inverted and superimposed upon the other.

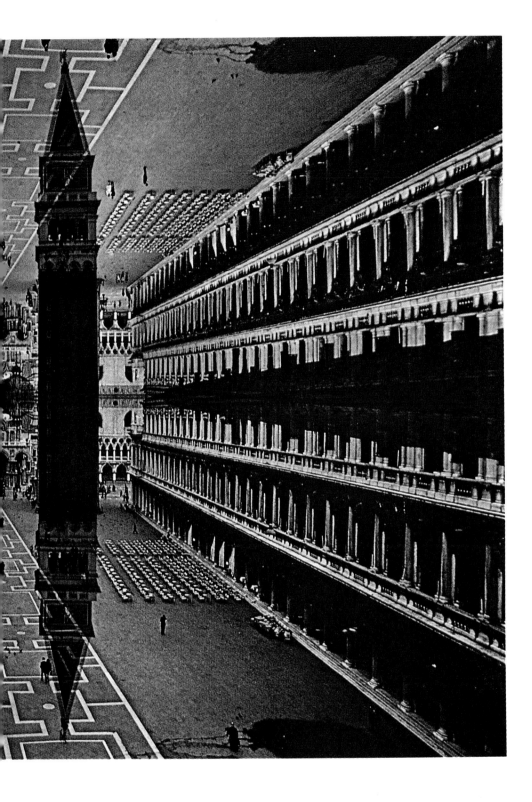

beforehand by combining different images on a light box until the right solution is found; and because the images remain separate throughout most of the process considerable control is possible.

Perhaps no other contemporary photographer has used this technique more effectively than Art Kane. He is young enough to have taken his first pictures when color film and color cameras had already moved out of their cumbersome infancy. Fifteen years before Kane made his first photographic

exposure, the tri-color camera had already been doomed to near obsolescence by the introduction of Kodachrome.

Art Kane's early training was in advertising and editorial design, and his early aspiration was to be an illustrator. Even before he graduated from the Cooper Union School of Art and Architecture in New York City, Kane worked in the art department of *Esquire* magazine, and a few years later he became art director of *Seventeen* magazine. During these early years

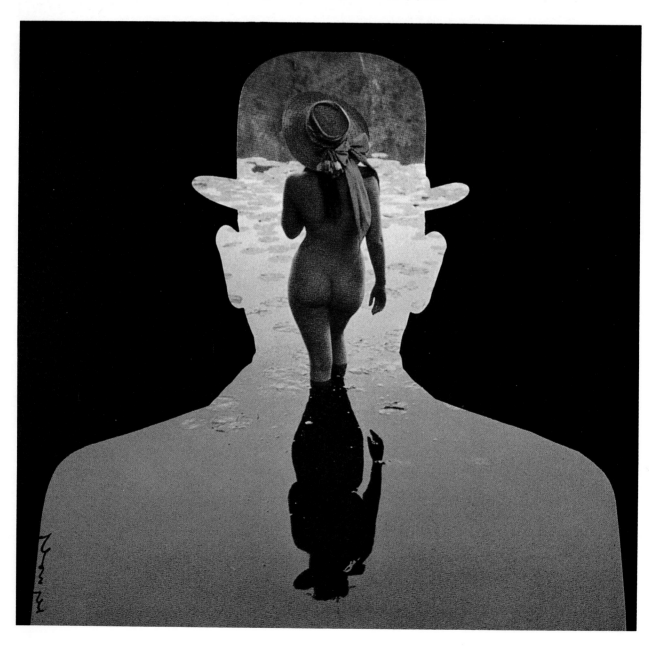

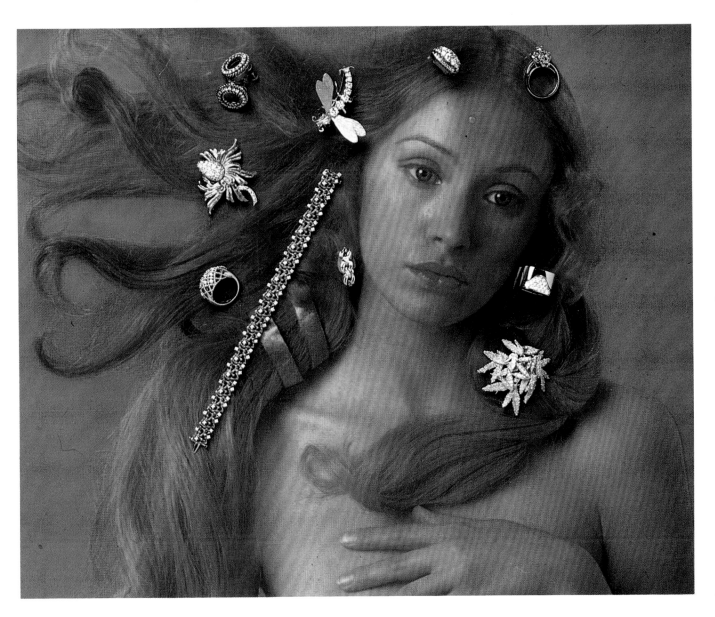

Designer-photographer Henry Wolf adds a pinch of lewdness to the nude image (left) by framing it in a sandwich silhouette of a bowler-hatted voyeur. Above, his still life of jewelry is arranged atop a print reminiscent of Botticelli's Birth of Venus.

he had no compelling urge to be a photographer; but at this juncture in his life a touch of fate intervened, and exposure to a course taught by Alexey Brodovitch, the man who helped to shape the careers of so many photographers, began to turn Kane's interest toward the camera.

Art Kane brought a perceptive eye and a keenly developed editorial sense to photography. He approached his subject matter with an emotional as well as an aesthetic sensitivity, and this approach to photography has a natural affinity to the sandwich technique. By combining the very different images

98

Look closely. This is Polaroid's new Time-Zero Supercolor film. It develops twice as fast as any other instant color film. Now you can see the moment on film as you still live it. Beginning at time zero, when the camera ejects the film, the image is alive. You first see it at 10 seconds. At 30 seconds, it's getting stronger, clearer. And at 60 seconds, it appears complete. Moment and picture become one. Look again at the unretouched Time-Zero Supercolor picture. It was shot in a studio with a Polaroid SX-70 Sonar Land camera. The image is sharp. The colors are brilliant and dazzling. With excellent saturation, superb separation. Colors that once seemed impossible to obtain in instant photography are now possible. Colors that once seemed to melt together are now pure and distinct. Time-Zero Supercolor can be used in any Polaroid camera that takes SX-70 film, including the OneStep, Pronto Sonar, and SX-70 Sonar models. Polaroid's Time-Zero Supercolor film makes instant photography more exciting than ever.

At last, the time difference between taking a picture and seeing a picture has been reduced to virtually zero. This is Polaroid's new Time-Zero Supercolor film, the world's fastest-developing color film. From the instant this new film leaves the camera, the image is alive. You first see it at 10 seconds. At 30 seconds, it's growing stronger, clearer. And at 60 seconds, it appears complete. Suddenly, the moment and picture become one. Look closely at the Time-Zero Supercolor picture. It's unretouched. The image is sharp. The colors are rich and bright. With superb saturation and separation. It was shot by a professional using a Polaroid SX-70 Sonar Land camera. Now you can get the same dazzling color and clarity because new Time-Zero Supercolor can be used with any Polaroid camera that takes SX-70 film, including the OneStep, Pronto Sonar, and SX-70 Sonar models. Time-Zero Supercolor is a new experience. Its color, sharpness, and developing speed make instant photography more exciting than ever.

In an eye-catching series of advertisements for Polaroid film, photographer-designer Helmut Krone uses print to carry the color image of a woman (left) and a highway sign (above). The shadow effect is achieved by exposing each four-color separation of the color print through a negative of the type. In the final version, color tones are picked up by the type and disappear where there is no type.

of metal bars with a human face (see page 93), Kane has completed a simple but powerful editorial statement. By combining two nearly identical images, but placing one image upside down, Kane has achieved an element of surprise and made a surrealistic statement (see pages 94-95).

Art Kane's photographs frequently reach out to the unexpected to create eye-arresting images, and this introduction of surprise probably explains the success of his editorial statements. Those of us who have worked closely with him soon become aware of the amount of thought and the almost endless planning that lies behind these images. When we encounter Kane's stark, often lyrical, and always superbly controlled pictures, we know we are faced with an emotional and intellectual as well as aesthetic experience.

Variety in photo/graphics: This book has only been able to tap the surface of the variety of approaches to photo/graphics that are available to the photographer, art director, and illustrator. The closing pages are made up of a sampling of the subtle and sometimes powerful ways in which these techniques have been used to get viewer attention and convey ideas. Two designers who have made unique contributions to photo/graphics and

100

These calendar illustrations by
photographer Sam Haskins depend
upon simple sandwiches to show a
model (left) on large sheets of
paper and to superimpose fish on a
fishing scene (above).

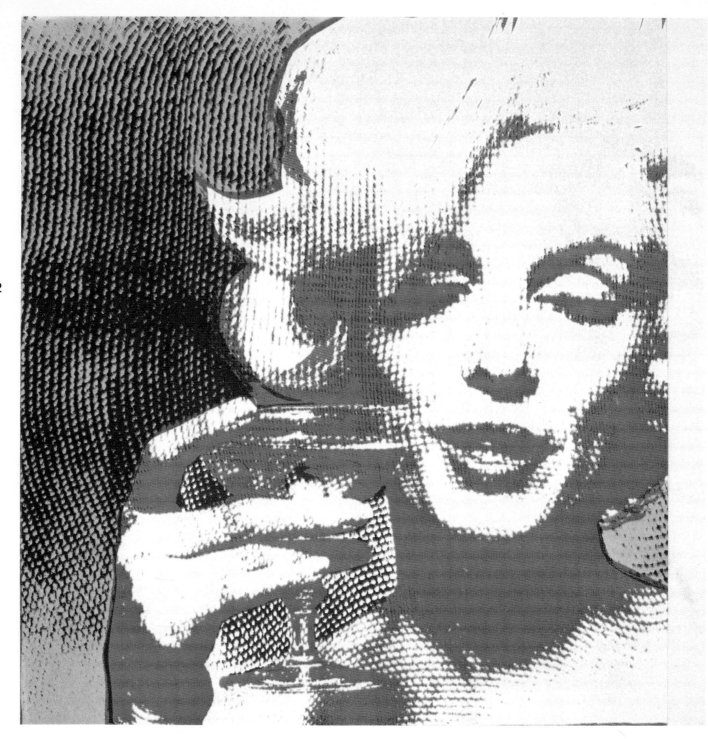

The special effects Bert Stern gave his images of Marilyn Monroe were achieved by using black-and-white exposures transferred to silk screens and then printed in colors not normally used in publishing.

are worthy of special note are Henry Wolf and Sam Haskins.

Henry Wolf is a fine example of a photo/graphic designer. The first phase of his career was spent as an art director of magazines, among them *Esquire, Harper's Bazaar,* and *Show.* Wolf then moved on to advertising where he established a unique success as a creative designer. The third phase of his career has been as a photographer, although he has not turned his back on design, and in many ways he is still as much a designer as he is a photographer. In fact, his involvement with the camera goes

back to his early career at *Esquire* where he created some outstanding cover photographs. His three careers—editorial designer, advertising art director, and photographer—have been a blend of creative power and communication ideas.

Sam Haskins is also very much a photo/graphic designer. At the time that I was working on my original plan for the lecture that eventually lead to the writing of this book, Haskins was preparing his own impressive book, *PhotoGraphics.* The two images from that book (see pages 100-101) are good examples

of his particular photo/graphic style. He believes that the ability of collage and superimposition to bring together unrelated images is basic to surrealism and that these methods can create the pleasant shock sensation that he is after. Haskins also feels that montage is an effective way to illustrate the complexity of modern life.

Retouching: The addition of darkroom technical effects to a photograph often creates unpredictable flaws, either in the print or transparency, which then must be smoothed out or eliminated. This is the retoucher's

For a pharmaceutical advertisement, photographer Peter Angelo Simon created this uptight image by projecting the photo of a face onto a clenched fist.

This tile-floored grotto with its
stranded fish was created by
double exposure in photographer
Mimmo Franca's camera for a tile
company's sales booklet.

job; he is the technician who applies the final touches. When retouching was first applied to photographs, it was essentially a correcting medium; but as images and communication needs became more sophisticated, more creative approaches came into being. Early retouching was accomplished almost exclusively with an airbrush; today retouchers rarely use the airbrush. Instead, they depend on dyes and bleaches that can change a photograph without obscuring it.

Emilio Paccione is an outstanding retoucher who is committed to the bleach-and-dye technique (see page 112). Recently, in an article that appeared in *American Photographer,* Paccione described

106

Illustrating an advertisement for thorazine (left), photographer Robert Rich projected a woman's face onto rectangles and cylinders made of computer punch cards. Peter Angelo Simon used a similar technique, projecting a child's face onto scattered blocks (above).

his duties as ranging from "basic retouching to original illustration to everything else required including the kitchen sink." He went on to say, "You can't really learn retouching at school. Teachers know airbrushing and basic spotting, but they don't know what's really involved. You have to experience it on the job."

Summary: Color has added a new dimension to the art of photo/graphics. One of the first and simplest ways in which color can be manipulated is through the filter. The use of filters began as a method for correcting weaknesses in film sensitivity to light and as a means of intensifying the value of a sky; but today, with more sophisticated photographs, filters are not only used for correcting purposes, they are used for enhancing and altering colors as well.

When Richard Avedon was creating his psychedelic portraits of the Beatles, he began by converting his black-and-white negatives with color filters, but he soon moved on to more elaborate effects like solarization to add the color excitement that his pictures demanded. In the process, Avedon switched from film transparencies to dye-transfer prints for maximum control.

One of the most effective ways of achieving a photo/graphic effect in color is by combining images. This effect can be achieved by double exposure, montage, or by an even simpler technique of placing two transparencies together, which has become known as the sandwich technique.

Many contemporary photographers, some of whom have been trained in modern design schools, have created significant effects in the photo/graphic technique. The

For the German magazine Twen's *feature "The New Man," photographer Will McBride makes the point, "he is informed and political," by using closed-circuit video to bring the close-up image of an eye onto the television screen his model is holding.*

108

Paradox is the point of Otto Kasper's illustrations for a calendar titled, "Who Does Things Like That?" Photographs like this are made startling not by photographic technique but by manipulation of the subject.

examples on these pages can only hint at the wide range of options available to both designers and photographers. In addition to their use in photography, many of these techniques can also be used to solve problems in illustration. In searching for these technical solutions, the designer or photographer should also be aware of their limitations; there are many problems that call for a more straightforward solution, and much too often there is an emphasis on technique, which can override and obscure the subject matter.

Photographer Adolfo Fogli has used color solarization to convert this detail from a photo of an Olivetti computer to a design element for a series advertising the company's data-processing equipment.

Belgian artist Pierre Cordier
reverses the photographic process
to produce his "chemigrams."

Conclusion

One reason the emphasis in this book has been on creative rather than technical considerations is that technique is in a constant state of refinement and change while the concepts of photo/graphic design remain more or less stable. Photography and the graphic arts are now at a threshold of a new era, in which light and chemistry and the negative and positive principles are about to be smothered by an influx of electronic impulses. Today, the

True magic is the province of such master retouchers as Emilio Paccione, seen here in Ted Horowitz's photo, conjuring a woman up from a blank piece of paper.

computer stands by, ready to perform many of the functions that in the past required years of apprenticeship. This current threshold is thus not vastly different from the one that faced El Lissitzky, Man Ray, Edward Steichen, and Paul Rand in the 1920s and 1930s, when modern photographic technology was beginning to upset over four centuries of the Gutenberg tradition.

Today, young designers are faced with a challenge similar to the one which faced the pioneers of design half a century ago. If a designer can come to grips with this technical opportunity—and at the same time avoid the peripheral gimmickry that is too readily available—he or she will be rewarded with images that are both effective and enduring.

The computer has become a graphic tool that is capable of speeding up the translation of letters into words and sentences. Through the use of the scanner, a highly expensive, computerized machine, color has been made more available to the designer. The computer can also create its own images, although, so far, the best results have been confined to film

JOE EGAN : MAP SCALE 1:1

The computer's stereoscopic vision can be translated into portraits much like contour maps, as on this record jacket by Richard Seymour.

German designer Klaus
Kammericks goes beyond the
computer's contour portrait by
exaggerating its many layers in
wooden sculpture.

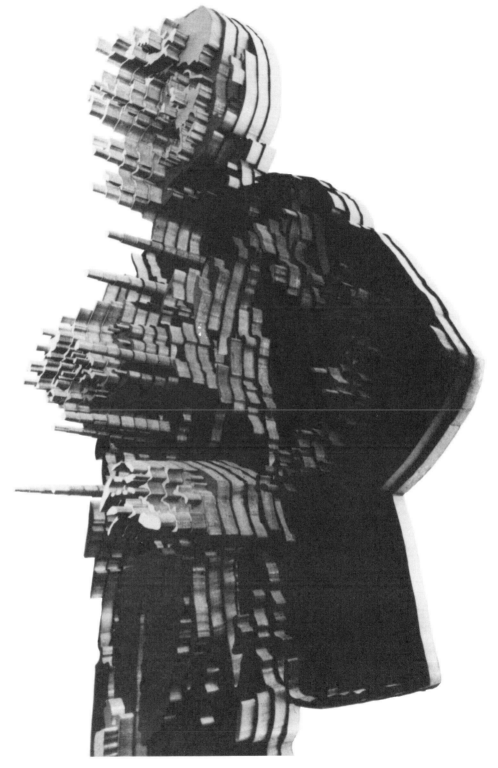

and television, where the imperfections of the image are blurred by motion.

The computer can break images down in ways that photographic devices and darkroom manipulation are incapable of. It can even take flat, black-and-white images and restore them to their original three-dimensional context. The dimensional photograph reproduced here (see page 115) is the result of a process invented by a West German designer named Klaus Kammericks. The process is similar to that used by cartographers to add dimension to flat maps. In this instance, Kammericks has taken the illusion of perspective revealed by the camera—a result not too dissimilar to the one Vermeer encountered in his camera obscura centuries before—and turned it from a perspectival image into a cognative experience. And this example only hints at the technical complexity that photographers and designers are faced with as they endeavor to extend the tradition of photo/graphic design.

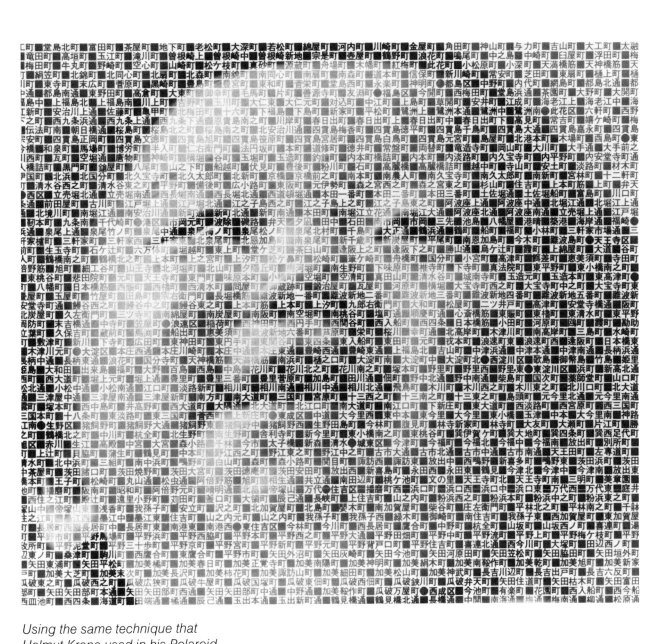

Using the same technique that Helmut Krone used in his Polaroid advertisements, Jungo Ikeguchi created this booklet cover for the city of Osaka by reproducing the face of a child in the characters that identify the city's blocks.

List of credits

Creativity: de Bono, Edward. *Lateral Thinking*. London, Pelican Books, 1977.

Collier, Graham. *Art and the Creative Consciousness*. Englewood Cliffs, N.J., Prentice-Hall, 1972.

Freud, Sigmund. *An Outline of Psycho-Analysis*. Translated by James Strachey. London, Hogarth Press, 1969.

———— *The Complete Introductory Lectures on Psycho-Analysis*. Oxford, Alden & Mowbry, Ltd., 1971.

———— *Jokes and Their Relation to the Unconscious*. London, Routledge and Kegan Paul, 1960.

Ghiselin, Brewster. *The Creative Process,* New York, New American Library.

Koestler, Arthur. *The Act of Creation*. London, Hutchinson, 1964.

Osborn, Alex. *Applied Imagination*. New York, Charles Scribner & Sons, 1953.

Simberg, A. L. *Creativity at Work*. Boston, Industrial Education Unit, 1964.

Storr, Anthony. *The Dynamics of Creation*. London, Sacker & Warburg, 1972.

Wallas, G. *The Art of Thought*. London, Jonathan Cape, 1926.

Woodworth, R., and Schlosberg. *Experimental Psychology*. London, Methman & Company.

Design: Arnheim, Rudolf. *Art and Visual Perception*. Berkeley, University of California Press, 1974; London, Faber and Faber, 1974.

Craig, James. *Production for the Graphic Designer*. New York: Watson-Guptill Publications, 1974.

Elffers, Joost, *Tangram, The Ancient Chinese Shapes Game*. London and New York, Penguin Books, 1976.

Garland, Ken. *Illustrated Graphics Glossary*. London, Barrie & Jenkins, 1980.

122

Gasser, Manuel. *Exempla Graphica,* An AGI Publication. Zurich, Hug & Sohne.

Glaser, Milton. *Graphic Design.* Overlook Press, 1973.

Gregory, R. L. *Eye and Brain.* New York: World University Library, 1973.

———. *The Intelligent Eye.* New York: McGraw-Hill, 1970; London: George Weidenfeld & Nicolson.

Gombrich, E. H. *Art and Illusion.* New York, Bollingen Series, 1961; London, Pantheon Books, 1960.

Herdeg, Walter. *Graphis Diagrams.* Zurich, Graphis Press; New York, Hastings House.

——— *Film & TV Graphics.* Zurich, Graphis Press; New York, Hastings House.

——— *Archigraphia.* Zurich, Graphis Press. New York, Hastings House.

Hoffman, Armin. *Graphic Design Manual.* New York, Van Nostrand Reinhold, 1965.

Hurlburt, Allen, *Layout, the Design of the Printed Page.* New York, Watson-Guptill Publications, 1977.

———. *The Grid.* New York, Van Nostrand Reinhold, 1978.

———. *Publication Design.* New York: Van Nostrand Reinhold, 1976.

Kepes, Gyorgy. *Education of Vision.* New York, George Braziller, 1965.

———. *Language of Vision.* Chicago, Theobald, 1945.

———. *The New Landscape.* Chicago: Paul Theobald, 1956.

LeCorbusier. *The Modulor.* Cambridge: Harvard University Press, 1954.

Lois, George. *The Art of Advertising.* New York, Harry N. Abrams, 1977.

Muller-Brockmann, Josef. *The Graphic Artist and His Design Problems.* New York, Hastings House, 1961.

Rand, Paul. *Thoughts on Design.* New York, Van Nostrand Reinhold, 1971.

Ruegg, Ruedi, and Frohlich, Godi. *Basic Typography: Handbook of Technique and Design.* New York, Hastings House, 1972.

Tolmer, A. *Mise en Page: The Theory and Practice of Layout.* London: The Studio Ltd., 1930.

Wingler, Hans M. *Bauhaus.* Cambridge: MIT Press, 1969.

Design Annuals: Art Directors Club. *Annual of Advertising and Editorial Art,* New York, 1921-present.

Herdeg, Walter. *Graphis Annual.* Zurich, Graphis Press; New York, Hastings House, 1952.

Coyne, Richard. *CA Annual of Design and Advertising.* Palo Alto, *Communication Arts Books,* 1958.

American Institute of Graphic Arts, *AIGA Graphic Design, USA,* New York, Watson-Guptill Publications, 1980.

Modern Publicity, London, Studio Vista.

Booth-Clibborn, Edward, ed. *Design and Art Direction, Nineteen Seventy Nine,* 17th Edition. New York, Hastings House, 1980.

Print Casebooks. Three six-volume editions of the best in graphic design from 1975 to 1980. R. C. Publications.

Design History: Baljev, Joost. *Theodore van Doesburg.* New York: Macmillan, 1975; London: Studio Vista, 1975.

Banham, Reyner. *Theory and Design in the First Machine Age.* 2nd ed. New York: Praeger, 1967; London: The Architectural Press, 1960.

Barr, Alfred H., Jr. *Masters of Modern Art.* New York: The Museum of Modern Art, 1959.

Bayer, Herbert, ed. *Bauhaus 1919-1928.* New York: The Museum of Modern Art, 1972.

Bojko, Szymon. *New Graphic Design in Revolutionary Russia.* New York: Praeger, 1972.

Constantine, Mildred, and Fern, Alan. *Revolutionary Soviet Film Posters.* Baltimore: John Hopkins University Press, 1974.

————. *Word and Image.* New York: The Museum of Modern Art, 1968.

Cooper, Douglas. *The Cubist Epoch.* London: Phaidon, 1970.

Drexler, Arthur. *Twentieth Century Design.* New York: The Museum of Modern Art, 1959.

Gray, Camilla. *The Russian Experiment in Art 1863-1922.* New York: Scribner, 1973; London: Thames and Hudson, 1973.

Klee, Paul. *The Inward Vision.* New York: Harry N. Abrams, 1958.

Moholy-Nagy, Sibyl. *Experiment in Totality.* Cambridge: MIT Press, 1969.

Kuppers-Lissitzky. *El Lissitzky.* London: Thames and Hudson, 1968; New York: New York Graphic Society, 1968.

Rubin, William S. *Dada, Surrealism, and Their Heritage.* New York: The Museum of Modern Art, 1968.

Selz, Peter, and Constantine, Mildred. *Art Nouveau.* New York: The Museum of Modern Art, 1976.

Scully, Vincent. *Frank Lloyd Wright.* New York: George Braziller, 1960.

Taylor, Joshua C. *Futurism.* New York: The Museum of Modern Art, 1961.

Van Doesburg, Theodore. *Principles of Neo-Plastic Art.* London: Lund Humphries, 1969.

Illustration: Fawcett, Robert. *On the Art of Drawing.* New York: Watson-Guptill, 1958.

Herdeg, Walter. *Graphis Diagrams.* New York: Hastings House, 1974; Zurich: The Graphis Press, 1974.

The Push Pin Style. Palo Alto, CA.: Communication Arts Books, 1970.

The Society of Illustrators. *The Illustrators Annual.* New York: Hastings House (1959-).

Photography: Herdeg, Walter, ed. *Photographis Annual*. New York: Hastings House; Zurich: Graphis Press (1951-).

Newhall, Beaumont. *The History of Photography*. New York: The Museum of Modern Art, 1964.

Pollack, Peter. *The Picture History of Photography*. New York: Harry N. Abrams, 1970.

Rothstein, Arthur. *Photojournalism*. New York: Amphoto, 1973.

Szarkowski, John. *The Photographer's Eye*. New York: The Museum of Modern Art, 1966.

Typography: Burns, Aaron. *Typography*. New York: Van Nostrand Reinhold, 1961.

Craig, James. *Designing with Type*. New York: Watson-Guptill, 1971.

Hlavsa, Oldruich. *A Book of Type and Design*. New York: Tudor, 1960.

Rosen, Ben. *Type and Typography*. New York: Van Nostrand Reinhold, 1970.

Ruegg, Ruedi and Frohlich, Godi. *Basic Typography: Handbook of Technique and Design*. New York: Hastings House, 1972.

Spencer, Herbert. *Pioneers of Modern Typography*. New York: Hastings House, 1970; London: Lund Humphries, 1970.

Swann, Cal. *Techniques of Typography*. New York: Watson-Guptill, 1969; London: Lund Humphries, 1969.

Index

126

127

Designed by Allen Hurlburt
Edited by Candace Raney
Graphic production by Ellen Greene
Text set in 10-point Helvetica Light